Alice Neel: Women

Carolyn Carr

RIZZOLI
NEW YORK

First published in the United States of America in 2002 by
Rizzoli International Publications, Inc.
300 Park Avenue South
New York, NY 10010

Assistance with research and documentation was graciously
provided by Robert Miller Gallery, New York.

For more information on Alice Neel, visit www.aliceneel.com

2002 2003 2004 2005 2006 / 10 9 8 7 6 5 4 3 2 1

Library of Congress Cataloging-in-Publication Data available upon
request

ISBN (hardcover): 0-8478-2434-9
ISBN (paperback): 0-8478-2480-2

Designed by Hotfoot Studio

Printed in Italy

Front cover, counterclockwise from left: *Eka, Lida, Woman in Cafe,
Dick Bagley's Girlfriend, Linda Nochlin and Daisy, Charlotte Willard*
Back cover, counterclockwise from left: *Faith Ringgold, Spanish
Woman, Three Puerto Rican Girls, Josephine Garwood, Louise Lieber*

Front endpapers, clockwise from the left: *Woman,* 1936. Pencil on
paper. 15 x 10 in.; *Helen,* 1962. Ink on paper. 13 ¾ x 16 ½ in.; *Two
Puerto Rican Girls,* 1956. Ink on paper. 16 ½ x 14 in.; *Young
Woman,* 1956. Ink on paper. 14 x 11 in.; *Bette Fisher,* 1965. Ink on
paper. 14 x 11 in.; *Standing Nude,* 1932. Pencil on paper. 14 ½ x
10 ½ in.; *Jo Hefter,* 1959. Ink on paper. 18 x 12 in.; *Bette Fisher,*
1967. Ink on paper. 12 x 9 in.

Back endpapers: images are the same as the front endpapers.

**Alice Neel: Women
Mirror of Identity**
Carolyn Carr 4

Plates

Alice Neel: Women
Mirror of Identity

Carolyn Carr

Human beings were Alice Neel's favorite subject. Although she painted landscapes, urban vistas, and still lifes throughout her career, according them the same keen scrutiny she gave the likenesses of her living models, portraiture anchored her art. Calling herself a "collector of souls," Neel explored the human comedy by depicting a vast array of men, women, children, and couples.[1] Most were young, some were old, a few were rich, but many were poor. Neel was drawn to her subjects, however, less by their age or social status than by the way in which their outward attributes served to reveal their inner self and the era in which they lived.[2] Neel painted primarily from life because, as she willingly recognized, "I get something from the other person."[3]

Neel was justly proud of her five-decade love affair with the objective world. Despite the avant-garde's infatuation with abstraction in the late 1940s and 1950s, she persisted in rendering the richly textured realm that she saw before her. When given credit for "having preserved the figure when the whole world was against it," she gladly accepted the honor.[4] While not entirely alone in this mission, Neel was unswerving in her passion for the figure and in her crusade on its behalf.[5] And indeed, it is through her compelling portraiture that she has staked her claim to a place in the art-historical pantheon.

All art manifests some aspect of the autobiographical, but Neel's oeuvre is particularly revealing. She rarely

received a commission until late in life, so her choice of subjects was for the most part a matter of self-selection. She reveled in this freedom. Despite its economic consequences, she found the ability to choose whom and what she painted "very liberating."[6] Art was also the arena to which Neel retreated when she was confronted with an emotionally troubling situation or an event she could not control. It was the source of her psychic salvation. As she candidly admitted, "The minute I sat in front of a canvas, I was happy. Because it was a world, and I could do as I liked in it."[7] Moreover, as she matured, so did her art. "My work," she acknowledged, "is biographical in a way, and it changed with the times, not really in essence but to a certain extent outwardly."[8]

`Neel often told those who interviewed her that all art is history.[9] In her history and in her art, men played a major role. Neel loved the company of men. She enjoyed them as friends, as colleagues, as neighbors, and as lovers. When she sat down to paint them, she relished, as in all her work, the exploration of their physical being as a key to their hidden self. But in Neel's portraits of women—herself included—there emerges another level of meaning. In these portraits—whether depicting Madonnas with their infants, her art-school classmates, her impoverished neighbors, her art-world colleagues, or her sons' wives and her grandchildren—there is a personal exchange in the choice of subject and in the execution of the work that can be read as a comment on the artist as well as the sitter.[10] These portraits are not merely a catalogue of whom Neel knew and when, but also a chronicle of her conflicts and struggles as a young woman and, ultimately, a diary of her personal growth and psychic resolution.

· · ·

Alice Hartley Neel was born in Merion Square, Pennsylvania, but shortly after her birth on January 28, 1900, her family moved to the Philadelphia suburb of Colwyn. The precocious Neel found the town culturally limiting. In many ways, she found her family life equally unsatisfactory. Her mother, who was proud of being a descendant of a signer of the Declaration of Independence, provided the young Neel with her introduction to literature and the performing arts, but she was also "a woman of iron will who was unable to compromise." Her father, a mid-level employee of the Pennsylvania Railroad, was to a large extent emotionally aloof.[11] The family's distance from each other and Neel's perception of their dronelike roles in life is apparent in her 1927 drawing *The Family,* done shortly after she had become a mother herself [fig. 1].

As a young adult, Neel initially played the dutiful daughter. After graduating from high school in 1918, she took the Civil Service exam and went to work in Philadelphia as a clerk for the Army Air Corps. For about three years, Neel held a variety of modest jobs that paid relatively well, but her dissatisfaction with the status quo and her rebellious nature—so fundamental to her persona that it seemed programmed into her DNA—led her to quit working and enroll in the Philadelphia School of Design for Women, now the Moore College of Art. Neel defended her choice of this less prestigious of Philadelphia's two art schools, stating that she "didn't want to go to the Pennsylvania Academy of the Fine Arts because I didn't want to be taught Impressionism, or learn yellow lights and blue shadows. I didn't see life as a *Picnic on the Grass.* I wasn't happy like Renoir."[12]

Art school provided Neel with satisfaction on numerous levels. There she found a coterie of friends, recognition of her talent, and, while attending the Chester Springs summer

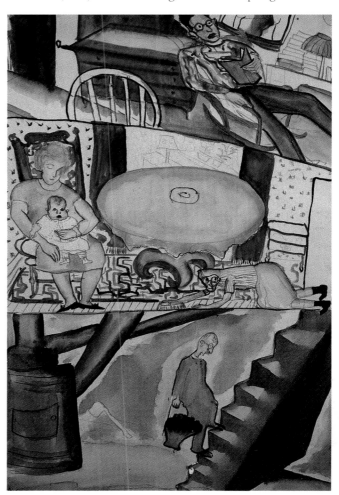

Figure 1 **The Family**, 1927.
Watercolor on paper. 14½ × 9¾ in. (36.8 × 24.8 cm.)

art school in 1924, her future husband, Carlos Enríquez de Gómez, a fellow artist from a wealthy Cuban family. The two married the following year, shortly after Neel's graduation from the Philadelphia School of Design. Carlos returned to Cuba in the fall, but Neel did not join him until January. The following December, their daughter Santillana was born. Initially the couple lived amidst the material abundance of the Enríquez household, but eventually Neel and Carlos rented a small apartment elsewhere in Havana, one that was more in keeping with Neel's lifelong egalitarian instincts and her desire to live a lifestyle that was conducive to creating art. Nevertheless, discontent pursued Neel and in May 1927 she left Cuba. She returned to her family in Colwyn and stayed with them until October, when Carlos was able to join her. They then moved to New York.

Typical of a mother in the 1920s with no domestic help, the burden of child care fell to her [fig. 2]. She also quickly learned that, as a poor woman, services for her child could be inadequate. In *Well Baby Clinic,* Neel evokes the menacing chaos and frighteningly impersonal world of public medical care [fig. 3]. Her macabre vision suggests the twentieth-century perpetuation of a visual tradition often associated with the nineteenth-century Belgian expressionist James Ensor.

Any personal peace that Neel may have initially found with the move to New York was severely undermined the following December, when the year-old Santillana died of diphtheria. Despite the birth of her second daughter, Isabetta (Isabella Lillian), in November 1928, a tranquil family life continued to elude Neel. In May of 1930, Carlos returned to Cuba with Isabetta [Pl. 110].[13] Neel's grief is poignantly conveyed in *Futility of Effort*, while *Symbols* evokes the ritualistic sacrifice and martyrdom she associated with childbearing

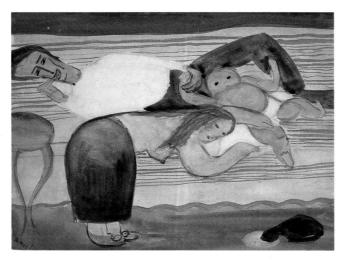

Figure 2 **The Family**, 1927.
Watercolor on paper. 9 × 12 in. (22.9 × 30.5 cm.)

[figs. 4, 5].[14] In retelling her story, Neel frequently spoke of her ambivalent feelings regarding motherhood. She understood all too well the conflict between her role as a parent and her need to be an artist.[15] Yet regardless of what Neel subsequently said, and despite very real obstacles and traumatic events, Neel's paintings from the late 1920s and early 1930s show that she also found previously unknown emotional satisfaction in being a mother. In several small paintings and watercolors, which featured both herself and others, she paid homage to the age-old role of the Madonna, the loving, nurturing female figure whose bond with her child is immutable [Pls. 1, 2]. To capture this sacred relationship, Neel employed a centralized format utilized by countless Renaissance painters. Undoubtedly, she knew this imagery both from books and from works in the Philadelphia Museum of Art, but she transformed the idealized, historical prototype by depicting herself and her neighbors. Neel returned to the theme of the Madonna in various guises throughout her life. Its formal evolution and the accompanying emotional transformations of this motif also serve as a bellwether of Neel's own metamorphosis.

Despite family obligations and personal tragedies, the innately gregarious Neel made numerous new friends in her first years in New York, among them Fanya Foss and Nadya Olyanova. Foss typified the intellectuals to whom Neel was attracted, while Olyanova personified the bohemians, gaining Neel's admiration as one committed to a life that did not encompass mainstream mores. Neel explored multiple facets of their personalities in several oils and watercolors. In her two portraits of Foss, Neel expresses both admiration and annoyance [fig. 6, Pl. 17]. In the painting, her friend poses in a demure, unassuming manner; in the watercolor, she is seated prominently among a group of women, baring her breasts. With X-ray vision Neel zeros in on her friend's pride of mind, which, it would appear, was intimately tied to her sexual vanity. Numerous oils and watercolors of Olyanova made between 1928 and 1933 show her as detached and self-absorbed [fig. 7]. In *Degenerate Madonna,* Neel underscores Olyanova's unconventional attitude by depicting her as a non-nurturing female flanked by ghostlike children [Pl. 3]; *Nadya Nude* and *Nadya and Nona* imply her casual willingness to boldly flaunt her sexuality [Pls. 109, 108]. As Neel later reflected, "I always said that there was a struggle between her head and her central section, and the head is losing."[16]

Shortly after Carlos left for Cuba, Neel returned to stay with her parents. To mitigate her emotional anguish, Neel sought solace in trips to the Philadelphia studio of her former

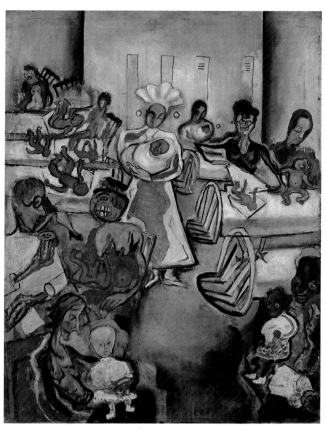

Figure 3 **Well Baby Clinic**, 1928–29.
Oil on canvas. 39 × 29 in. (99.1 × 73.7 cm.)

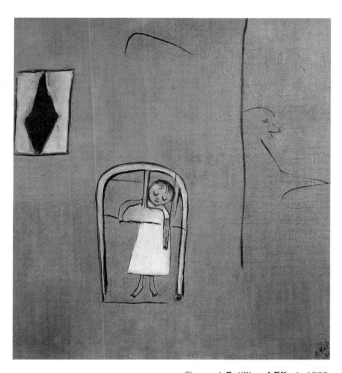

Figure 4 **Futility of Effort**, 1930.
Oil on canvas. 26½ × 24½ in. (67.3 × 62.2 cm.)

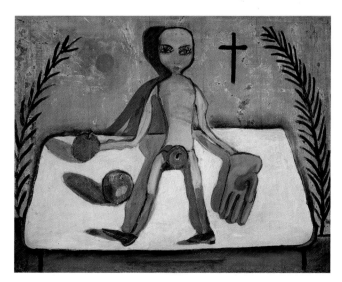

Figure 5 **Symbols**, c.1933.
Oil on canvas. 25 × 28 in. (63.5 × 71.1 cm.)

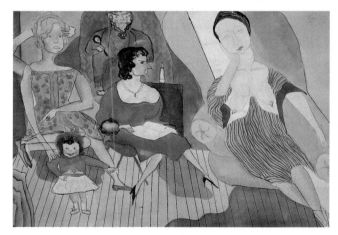

Figure 6 **The Intellectual**, 1929.
Watercolor on paper. 10½ × 15 in. (26.7 × 38.1 cm.)

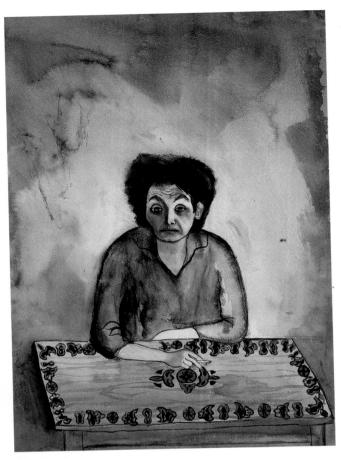

Figure 7 **Nadya**, c.1932.
Watercolor on paper. 14 × 10 in. (35.6 × 25.4 cm.)

art-school colleagues Rhoda Myers and Ethel Ashton. Both served as models for her [Pls. 107, 106]. Ashton, a big-boned and large-breasted woman, stares fearfully at the unseen artist. With the exception of the decorative pattern of the fabric on the left of the painting, her flesh awkwardly consumes the canvas. Using pictorial devices such as shallow space, flattened forms, contrasting light and dark areas, and distortion drawn from the visual vocabulary of Cubism and Expressionism, Neel created an image of a woman not comfortable with herself. Painfully aware of the observer, she is, psychologically, the antithesis of Olyanova.

Neel's memorable portrait of Myers shows her seated and nude, dressed only in pearls and a wonderful blue hat. Stylistically, the flat forms, attenuated anatomy, encrusted paint, and dark outlines in *Rhoda Myers with Blue Hat* suggest Neel's familiarity with the work of Georges Rouault or perhaps Max Beckmann [Pl. 105].[17] While the partially dressed figure has been a traditional means of expressing sexual enticement, Neel's image of Rhoda was not about seductiveness. The bored, distracted visage, the roughness of the flesh, and the flatness of the breasts are rendered so that nothing invites the viewer to touch, gaze, or be aroused. Moreover, the manner in which the form occupies the foreground and fills the frame of the canvas metaphorically forbids the viewer to enter the space of the observed. Neel's self-possessed figure invites comparison with Edouard Manet's nude in *Déjeuner sur l'herbe* (1863; Paris, Musée d'Orsay), for her intent, like his, is to strip the flesh of idealization and to express the reality of nakedness.[18] Just as Manet's modern, lifelike nude signified his delight in challenging accepted custom, *Rhoda Myers with Blue Hat* was likewise a symbol of the bohemian lifestyle that the subject and the artist, both raised in the cocoon of conventionality, cherished.[19]

Neel frequently returned to this visual trope of nakedness and nudity—or the suggestion of it—later in life.[20] A number of sitters in the 1960s and 1970s speak of the fact that Neel asked them to pose nude. Some of those approached refused, but others accepted her invitation.[21] Those who were willing to defy convention usually said yes; those who were more reserved, or shocked at the request, usually said no. For Neel, the question was often a device to test her subject, a matter of her will or theirs. She also realized that the question simultaneously unnerved and relaxed her subjects. Those who were unnerved relaxed considerably when they sat for a more conventional portrait.

In August 1930, unable to reconcile her conflicting emotions of anger and guilt, or to clarify a future that suited her ambitions, Neel suffered a nervous breakdown. Always the observer, Neel characterized her hospitalization with a keen eye for the details of its reality [fig. 8]. When she was discharged in September 1931 from Gladwyne Colony, a private psychiatric hospital, she gratefully accepted an invitation from Olyanova and her husband to visit them at their home in Stockton, New Jersey. There she met Kenneth Doolittle, a sailor. Acknowledging the improbability of Carlos rejoining her, Neel moved with Doolittle to an apartment in Greenwich Village in January 1932. Neel remained with him until December 1934, when, in a jealous pique, he destroyed numerous paintings, drawings, and watercolors.[22] Neel then turned to John Rothschild, a relatively well-to-do Harvard graduate she had met in the spring of 1932, for emotional and financial support [fig. 9]. While Rothschild remained a lifelong friend, in 1935 Neel began living with guitarist and nightclub singer José Santiago. In 1939, shortly after the

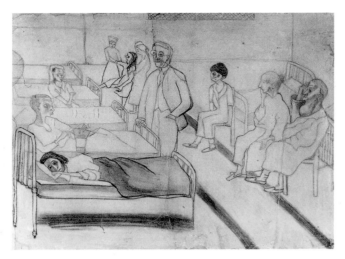

Figure 8 **Suicidal Ward, Philadelphia General Hospital**, 1931.
Pencil on paper. 17 × 22 in. (43.2 × 55.9 cm.)

birth of her son Richard, he left Neel. In 1940 she met film-maker and photographer Sam Brody, who lived with her intermittently for nearly two decades. Her second son, Hartley, was born in 1941.

Although Neel's personal life throughout the 1930s was relatively tumultuous, she was nevertheless single-minded in her attempt to establish herself professionally. She participated in several group exhibitions, had a solo show, and garnered her first newspaper notice.[23] She also found a modicum of financial stability by participating in various federal programs established to support artists during America's Great Depression, including the Public Works of Art Project (PWAP) and the Work Projects Administration (WPA).[24] Her portraits of women in the mid- to late-1930s, particularly those drawn from life rather than memory, are, however, relatively few. A far larger number of urban vistas, socially-oriented narratives, and piercing portraits of men remain, in all likelihood both a reflection of subjects favored by the WPA and her own interests and inclinations.[25] Nonetheless, the extant images of women reveal Neel's restless exploration of structure and color as signifiers of the soul of the sitter.

In both *Woman with Blue Hat* and *Elenka*, Neel securely anchors her subjects along a strong vertical axis, albeit one slightly off-center [Pls. 73, 18]. In each portrait the women appear self-possessed, but their temperamental difference is apparent. The woman in the blue hat is clearly lost in personal reverie as she calmly submits to the artist's gaze, while Elenka appears wholly engaged in the process of being painted. Characteristically, Neel brings the subject and the

viewer together in both these portraits by placing the sitter on the forward plane of the canvas. In *Woman with Blue Hat*, Neel partially sketches in varying shades of blue behind the figure, reiterating and reinforcing the hue that shapes the figure. The right of the canvas is white as if unpainted, a technique that opens up the space behind the figure and underscores its strong contour. This pictorial device is one that Neel will use repeatedly in her portraits of the last two decades of her life. The background in *Elenka*, by contrast, is a series of densely painted rectangles. These strong forms, together with the warm, intense colors, serve to reiterate the strength and intensity of her personality. The emotional calm pervading these portraits also suggests that, despite her own peripatetic existence, Neel was gaining an emotional equilibrium that had previously eluded her.

When Neel, the consummate observer, gave birth to her first son, Richard, in September 1939, she paid homage to this event in *Childbirth*, a portrait of her hospital roommate Goldie Goldwasser [Pl. 111]. Employing her vivid memory, Neel captured her feelings and those of any new mother who has just survived the travail of delivery by showing Goldwasser with her breasts engorged, her stomach empty but still distended from the bulk of the fetus, which it has just disgorged. The physical and emotional toll of labor is symbolized by the rumpled sheets, Goldwasser's dislocated

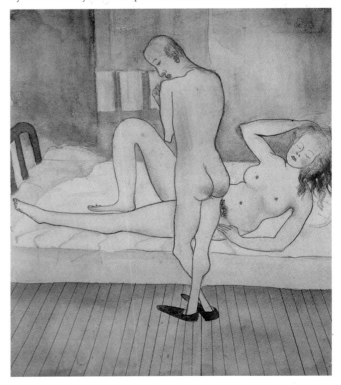

Figure 9 **Alienation**, 1935.
Watercolor on paper. 10½ × 9 in. (26.7 × 22.9 cm.)

arms, and the dark circles under her eyes. The requisite congratulatory bouquet of flowers, the only stable, immobile form in the entire composition, rests complacently on the bedside stand. To explicate the reality of childbirth, Neel has drawn on the vocabulary of Cubism. But the Cubism she references is not the angular style of the young Pablo Picasso, but the soft, undulating style that he employed in the early 1930s in works such as *Nude on a Black Couch* (1932; Private collection), one of his lyrical and loving portraits of Marie-Thérèse Walter. While Neel conveys observable facts in *Childbirth*, as she did in *Ethel Ashton*, the curvilinear rather than angular lines and the space between the figure and the viewer in the later work connote sympathy, not detachment and disdain. Recalling the painting more than thirty years later, Neel said, "I telescoped the whole thing together. . . . What you see is empathy. You are not aware of your shoulders when you are in labor, so I left the shoulders out."[26]

Neel moved to Spanish Harlem in 1938, living first at 8 East 107th Street and then, from 1942 until 1962, at 21 East 108th Street, between Fifth and Madison Avenues. Her neighbors and their children were frequent subjects. In *Puerto Rican Mother and Child* (1938), *The Spanish Family* [Pl. 4], and *Black Spanish-American Family* [Pl. 5], Neel returned to the theme of the Madonna and Child that she had first explored a decade earlier. Now, however, the figures in these compositions are less idealized, and they are disposed across the canvas in a more relaxed, less hierarchical manner. The mothers are clearly more at ease with their maternal role than those depicted previously. In *The Spanish Family*, Neel employs a multi-figured composition that shows a new interest in exploring more complex formal arrangements and the psychological dynamics that accompany them. Here Neel also makes use of the decorative and spatial effect of the metal grillwork behind the figures, much as Manet did in *The Railway* (1873; Washington, D.C., National Gallery of Art). In the 1970s Neel remembered the mother, whose husband was in the hospital suffering from tuberculosis at the time of the painting, as "very bright and [a woman] who had lots of courage."[27] Her words have a resonance beyond the painting. In both the family portraits and in the single images done in the 1940s and early 1950s, it is evident that Neel admired and empathized with the quiet strength and intrinsic dignity of her Spanish Harlem neighbors, perhaps seeing in them her own growing confidence and resolve.

Neel's art is about theme and variation, and in the 1940s she again picked up the theme of the nude in her portraits. *Sue Seeley, Nude* [Pl. 113] is Neel's homage to Giorgione and

Titian, an amalgam of the *Sleeping Venus* (1510; Dresden, Gemäldegalerie) and the *Venus of Urbino* (1538; Florence, Uffizi Gallery). This amply endowed woman—a type that repeatedly captured Neel's imagination—reclines in a landscape, complacently but seductively contemplating the viewer, as her late-Renaissance pictorial ancestors had done before her. *Pat Ladew* [Pl. 114] has the same ancestry, but the visual gene pool is augmented by the presence of a cat, an allusion to Manet's *Olympia* (1863; Paris, Musée d'Orsay). The shallow space and the decorative drapery surrounding Ladew suggest that Neel also assimilated a taste for abstract patterning of the kind that can be found in numerous works by Henri Matisse.

Neel's portraits in the early 1940s include her vitriolic rendering of Audrey McMahon, the director of the New York division of the Work Projects Administration [fig. 10]. While not from life, it embodies Neel's anger at her temporary dismissal from the government's art program in the early 1940s, as well as her distaste for self-satisfied authority figures.[28] By contrast, Neel's portrait of an art dealer is a tribute to suave sophistication. The fashionable, upswept hairdo, casually held cigarette, and demeanor of detached skepticism connote a woman who would readily challenge the unseen viewer to provide witty and amusing conversation [Pl. 20]. When both of these works are juxtaposed to the simple, straightforward, somber-paletted image of Josephine Garwood, a woman Neel met through a mutual friend, they again underscore the variety of types Neel represented as well as her ability to render personality through simple details—the tilt of the head, the placement of a limb, the expression, and the color of costume [Pl. 40].

Neel's circle of friends in the 1940s and early 1950s, and hence subjects of her portraits, was comprised of left-wing activists such as Mercedes Arroyo and the African-American playwright and actress Alice Childress; supporters of artists and social causes such as Sarah Shiller and Elsie Rubin; and a variety of art-world notables [Pls. 78, 21, 23, 25]. As in the early 1930s, when Rhoda Myers and Ethel Ashton sat for her, fellow artists such as painters Dorothy Koppelman and Bessie Boris continued to serve as models [Pls. 38, 19]. Neel probably got to know Dore Ashton, a noted critic of Abstract Expressionism, through The Club, a group founded in 1949 by artists such as Willem de Kooning and Franz Kline to discuss issues related to contemporary art [Pl. 43].[29] Neel painted her portrait from memory rather than life, which in all likelihood accounts for the simplification and stylization of Ashton's face. The layered, intensely colored patches of

paint behind Ashton's head seemingly allude to the gestural brushwork of the Abstract Expressionists about whom Ashton often wrote. Neel employed a similar technique in her portrait of Sarah Shiller, but here the patches of paint behind the head of the sitter seem to be solely a structural conceit and without any implicit symbolic meaning. This pictorial device has numerous antecedents, among them Edgar Degas's portrait of Mary Cassatt (1880–84; Washington, D.C., National Portrait Gallery).

Neel's life in the 1950s—when she was in her fifties—was marked by a series of changes in her personal life. In 1953 Richard left for High Mowing, a boarding school in Wilton, New Hampshire; Hartley followed in the fall of 1955. Although her sons demanded less of her attention, Neel's mother, Alice Concross Neel came to live with her in 1953. She died the following year, following a fall and complications from a broken hip. Neel marked the passage of her mother's final year with a series of portraits of nurses and a portrait of her. Her empathetic rendering of one of her mother's caregivers, seated with downcast eyes and clasped hands, suggests a quiet but commanding patience [Pl. 46]. The mood is the antithesis of that evoked twenty years earlier, when Alice herself was the focus of the health-care system [fig. 8]. The portrait of her mother, the last full-scale rendering of this woman whose confined, traditional lifestyle Neel sought desperately to avoid, describes candidly, but sympathetically, the realities that a late-in-life illness imposes [Pl. 45].[30]

By the end of the 1950s, both of Neel's sons were students at Columbia College; Sam Brody, who had an on-and-off track record in terms of their relationship, had moved out of the apartment permanently; and Neel, a welcomed member of a circle of younger and decidedly hip artists and writers, had appeared along with Allen Ginsberg, Gregory Corso, Jack Kerouac, Peter Orlovsky, and Larry Rivers in the Robert Frank and Alfred Leslie film, *Pull My Daisy*. In the following decade, Neel began to exhibit more frequently and in 1962 she was the subject of a feature article in *ArtNews*.[31] Energized by new personal freedom, new friends, new attention to her work—including several solo shows at the Graham Gallery—a new, larger apartment, and perhaps psychotherapy, which she began in 1958, Neel's work showed a new expansiveness.[32] The growing confidence and exuberance in Neel's art in the 1960s increased in the 1970s and became a hallmark of her style in the remaining decades of her life. Larger paintings, freer compositions, and the repeated use of bold colors came to characterize her art, although her basic desire to explore human nature remained constant. *Lida, Nude* has

Figure 10 **Audrey McMahon**, 1940. Oil on board. 23¾ × 17⅞ in. (60.3 × 45.4 cm.)

clear antecedents in Neel's oeuvre, but the greater scale of the painting, the vigor of the brushwork, the highly casual pose, and the self-possessed, confident gaze of the sitter speak to a new attitude on the part of the artist [Pl. 115]. Taken together, these qualities suggest not only the psychological comfort of the sitter—a friend who was a photographer—but also Neel's new self-assurance. The breathtaking contrast of the solid red suit of Geza's wife with the electric-blue background proclaim Neel's new daring with color [Pl. 52]. Neel had always been the master of anatomy as signifier and her ability to use arms to shape the composition and to connote mood and manner continues, whether constrained as in *Dick Bagley's Girlfriend* [Pl. 39], gesticulating insistently in *Bessie Boris* [Pl. 19], attenuated like a praying mantis in *Peggy* (1949), or supportive of the head of a contemplative sitter as in *Sarah Shiller* [Pl. 23]. But beginning with the small portrait of Elsie Rubin, and evident as well in the portraits of Mimi [Pl. 24], Eka [Pl. 27], Vivienne Wechter [Pl. 81], and Ava Helen Pauling, there is a loose casualness, a lack of

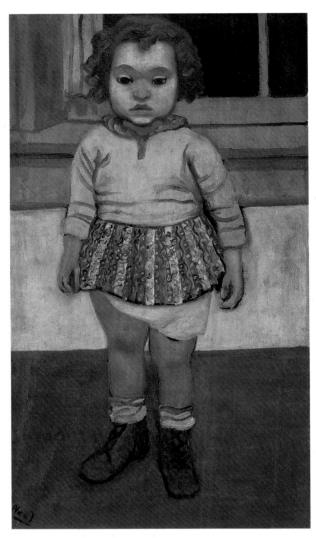

Figure 11 **Sheila**, 1938.
Oil on canvas. 32¼ × 18 in. (81.9 × 45.7 cm.)

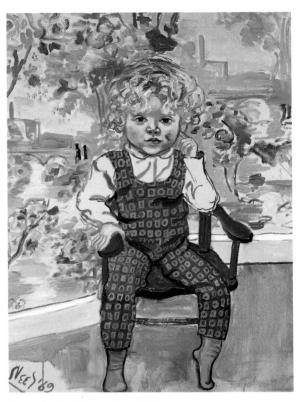

Figure 12 **Peff Modelski**, c.1949.
28½ × 22 in. (72.4 × 55.9 cm.)

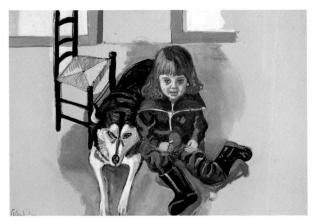

Figure 13 **Elizabeth and Lushka**, 1971.
Oil on canvas. 39 × 50 in. (99.1 × 127 cm.)

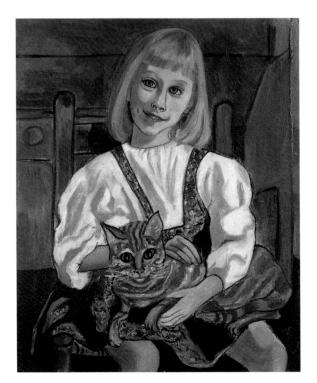

Figure 14 **Jenny**, 1969.
Oil on canvas. 35½ × 26 in. (90.2 × 66 cm.)

tension and constraint that seem to be qualities of both the artist and the sitter.

Throughout her career, Neel had always been attracted by unusual aspects of dress. Captivated by a commanding headpiece she saw on the streets of New York, she returned to her apartment and painted from memory *Woman in Pink Velvet Hat* [Pl. 76]. In the 1960s and 1970s, she repeatedly incorporated into a sitter's portrait—indeed, it may have been the element that provided the impetus for the sitting—distinctive aspects of dress: the draped scarf sported by Vivienne Wechter; the fur piece looping the neck of Ellie Poindexter like a fuzzy boa constrictor; the knit toque of Charlotte Willard; and the lamb's-wool collar of Dorothy Pearlstein's coat, which shares a visual analogy with her hair [Pls. 81, 80, 83, 58]. The hat may have first attracted Neel to Mary Shoemaker, but the gloves and the prim-collared coat must have pleased Neel as well, for such details addressed and confirmed her belief that inevitably every portrait subject spoke to his or her age [Pl. 82]. Neel was never shy about approaching strangers and did not know Shoemaker, whom she encountered as a bank customer, when she asked her to pose. Neel's portrait describes a woman who, although living in the mid-1960s amidst profound social change, recalled an era in which a woman of a certain standing never appeared in public without a hat and gloves, a woman who was shaped by the need to be proper, and one who was either unwilling or unable to break from this mold.

In the mid-1960s Neel's interest in the subject of the nude female was reinvigorated by the pregnancies of various younger acquaintances, as well as by the pregnancy of her daughter-in-law Nancy, whom Richard had married in December 1963. In these paintings, which represent a new variant on the theme of the nude, Neel relished every detail of the physical transformation of the topography of the female body. None of her subjects is timid, self-conscious, or overwhelmed; impending motherhood alters them physically but does not diminish them psychologically. *Pregnant Maria* directs a blasé gaze at the observer, posing on bedding that is as plump and as full as she [Pl. 116]. *Margaret Evans Pregnant* boldly occupies the frame of the canvas, while her reflection in the mirror hints at her other self—the thin version of before conception and after delivery [Pl. 123]. *Claudia Bach, Pregnant* reclines nonchalantly on a plump green sofa [Pl. 120]. Her dispassionate gaze connotes an emotional neutrality more often associated with the Pop and Minimalist art of the decade than with the traditionally romantic notions that surround motherhood.

Neel's friendship in the late 1960s with a younger generation and the birth of her first grandchild in 1967 also sparked her renewed interest in the theme of the Madonna and Child. Compared with previous treatments of this theme, the new canvases are larger, the compositions more complex, and the colors brighter and more intense. The children are not shy, reserved, or self-effacing, but rather are like Linda Nochlin's daughter Daisy: quick, eager, curious, and as self-possessed as their mothers [Pl. 11]. With *Nancy and Olivia* (1967), Neel embellished her composition by incorporating architectural space and still life into the richly textured whole; with *Nancy and the Twins* she employed a notably original horizontal composition [Pl. 9]. In *Ginny and Elizabeth,* a double portrait of Neel's other daughter-in-law—who married her son Hartley in 1970—and Ginny's firstborn, the Madonna theme is transformed into a lush symphony of color [Pl. 14]. While the abstract pattern of shadows is distinctly twentieth-century, the emotional tenor of the painting recalls the elegant turn-of-the-century interpretations of this theme by John Singer Sargent and William Merritt Chase. No longer directly burdened or overwhelmed by motherhood herself, Neel, with rare exception, depicted the rewards, rather than the responsibilities, of parenting. Her mothers are confident and comfortable in their role, qualities that may also reflect their economic status, which was considerably different from that of Neel and her Harlem neighbors when she herself was a young mother. *Carmen and Judy,* a portrait of the Haitian woman who came weekly to clean Neel's apartment, is an exception, suggesting that despite Neel's own changed circumstances, she never lost her empathy for the less fortunate [Pl. 10].

The birth of Neel's first grandchild, Olivia, also escalated the artist's interest in portraits of children. Beginning in the mid-1930s, when Neel undertook portraits of her daughter Isabetta, children had fascinated her [figs. 11–14]. She loved their innocence as well as their inherent sexuality, their acceptance of the world as it is as well as their anxiety as inexplicable events overwhelmed them. She loved their dress and the way their gestures and poses anticipated those of their adult counterparts. In Olivia, Neel found the perfect model. As an infant she was captive to her grandmother's intense and unrelenting gaze, but she soon became a willing participant, an actress in her grandmother's show, performing in a wide variety of costumes and stances [Pls. 98, 99, 86].

Neel's expanding family, particularly her ongoing access to her two daughters-in-law, gave her ample opportunity to

create a kaleidoscope of images exploring nuances of their personalities. Neel, who could be motivated to paint a portrait on the possibilities of color alone, probably began her 1968 portrait of Nancy inspired by the blue of her sweater and the pleasing effect generated by its contrast with her pink shirt [Pl. 55].[33] But the characterization that emerges as her daughter-in-law sits ramrod straight, supported by the plane of the table and framed by a pyramid of blue, gazing into space with the timelessness of an ancient Egyptian, is the personification of calm and patience. Ginny's striped shirt probably prompted a 1969 portrait, but the subject's bent knees and arms embody impatience, as if a wealth of other activities permitted her but a few minutes to pose [fig. 15]. Her froglike posture epitomizes what art historian and critic Ellen Johnson has described as Neel's ability to make those she painted appear awkward in order to heighten an aspect of verisimilitude.[34] In *Ginny and the Parrot,* Neel uses color to explore the exotic [fig. 16]. In *Nancy and the Rubber Plant,* Neel takes the restrained but commanding exterior demeanor of Nancy and uses it to anchor a portrait of heroic scale and complexity, one in which Neel experiments with still life as well as with interior and exterior architectural space [fig. 17].

Interspersed with the images of female family members that constitute much of Neel's work from the late 1960s until her death in 1984 are numerous portraits of prominent women in the art world, among them art historians Linda Nochlin, Ann Sutherland Harris, Mary Garrard, and Ellen Johnson (one of her rare commissions); artists Isabel Bishop, Faith Ringgold, Sari Dienes, June Blum, Irene Peslikis, and Marisol Escobar; art editor Susan Rossen; and curators Dianne Vanderlip and Catherine Jordan [Pls. 11, 15, 90, 65, 63, 67, 66, 60, 32, 68, 88, 61, 71]. Neel had always painted her friends who were artists—Ethel Ashton, Rhoda Myers, Dorothy Koppelman, Bessie Boris—only now, like art dealer Ellie Poindexter, critic and gallery owner Charlotte Willard, and Dore Ashton, these women were often well known to the culturally sophisticated. As Neel's reputation grew in the 1970s and her work was exhibited throughout the country, her friendships were no longer merely local. Many of her sitters were women who wrote about her paintings or exhibited them in shows that they organized. They were also feminists. And when they looked for role models, they found Neel, a woman who had not let erratic personal relationships, motherhood, economic deprivation, or lack of high-profile professional recognition diminish her commitment to her art.[35] As Neel's contacts expanded in breadth and public visibility, her late paintings repeatedly impart a sense of

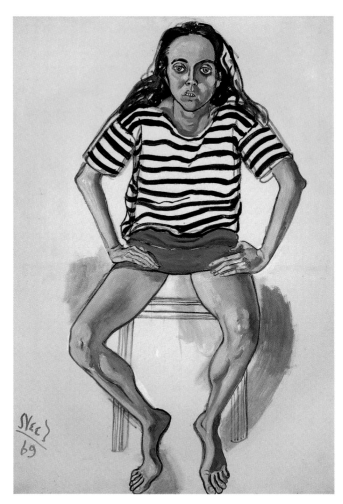

Figure 15 **Ginny in a Striped Shirt**, 1969.
Oil on canvas. 60 × 40 in. (152.4 × 101.6 cm.)

self-possession, connoting a bravado that is shared by both the subject and the artist.[36]

Although the vast majority of Neel's late work depicting women continues to focus on single figures, in the last decades of her life she occasionally undertook double portraits of adults, many of them art-world figures as well. Since many correspond in date to the portraits of mothers and their children, it may have been her renewed pleasure in exploring the psychological resonance of space, gesture, and posture in these multi-figured works that led her to instigate such portraits as *Red Grooms and Mimi Gross, Pregnant Julie and Algis,* and *Cindy Nemser and Chuck* [figs. 18–20].[37] Neel's interest in painting couples may also have been affected by the evolution of her own thinking about the nature of relationships. As she told one interviewer, "I grew up long enough

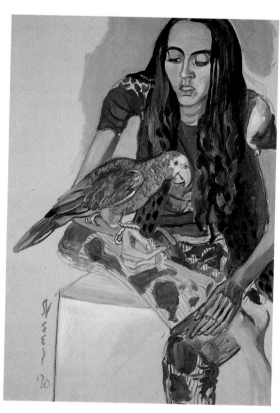

Figure 16 **Ginny and the Parrot**, 1970.
Oil on canvas. 36 × 24 in. (91.4 × 61 cm.)

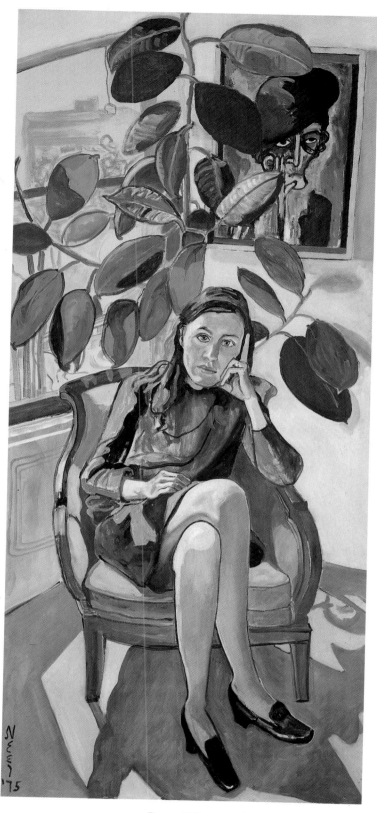

Figure 17 **Nancy and the Rubber Plant**, 1975.
Oil on canvas. 80 × 36 in. (203.2 × 91.4 cm.)

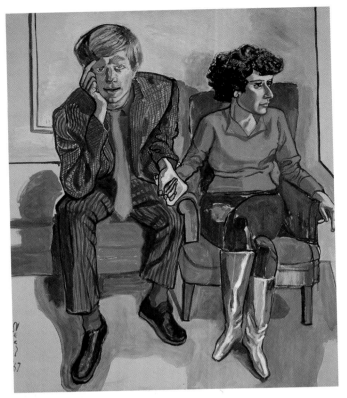

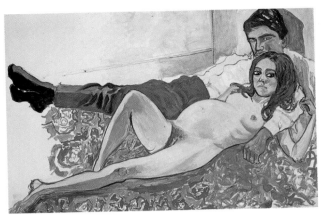

Figure 19 **Pregnant Julie and Algis**, 1967.
Oil on canvas. 42¼ × 63¾ in. (107.3 × 161.9 cm.)

Figure 18 **Red Grooms and Mimi Gross, no. 2**, 1967.
Oil on canvas. 60 × 50 in. (152.4 × 127 cm.)

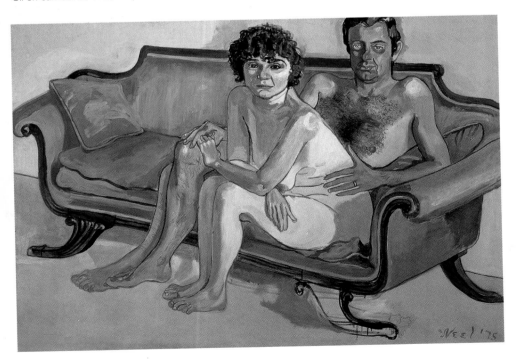

Figure 20 **Cindy Nemser and Chuck**, 1975.
Oil on canvas. 41½ × 59¾ in. (105.4 × 151.8 cm.)

ago that I realized that you have to please men. You want to please men, of course, because you're a girl and you want to have boyfriends and all that. Men have to please women, too. Of course. I learned that later."[38]

Like a therapist or family counselor, Neel used formal structure to tell a couple about their relationship. Neel persuaded Cindy Nemser, at the time editor of *The Feminist Art Journal,* and her husband Chuck, to shed their inhibitions along with their clothes, to undress themselves both physically and psychologically. Hardly traditional, it is nevertheless a loving portrait. Nemser sits demurely before her husband, shielding his nakedness, while he appears as the "behind-the-scenes" support of his wife's adventurousness.[39] Intimacy is also the watchword in the portrait of Julie and Algis, but artists Mimi Gross and Red Grooms fail to touch as they peer distractedly away from each other. Grooms, who admired Neel for her X-ray vision and "that killer line that describes everything," was initially unaware of the emotional distance between himself and his wife, but as he later noted, the painting of the two of them grew increasingly "more telling, especially in light of the fact that Mimi and I broke up."[40]

Neel's great self-portrait, which she began in 1975 and completed in the eighth decade of her life, sums up her approach to portraiture [Pl. 125]. It was painted from life but it also alludes to historical tradition. As Neel piercingly gazes into an unseen mirror with what art critic John Perreault deemed her "brilliant, mischievous eyes," her full-length form seated before the easel evokes the long tradition of artists painting themselves.[41] At the same time, her self-portrait eschews mainstream tradition by exploring the self without clothes. The nakedness of the unidealized body serves as a metaphor of the artist's candor.[42] Like all of Neel's paintings, the subject is revealed through expression, gesture, attributes, and physical fact. Her sure draftsmanship creates an image that evokes a moment but is imbued with universality. Her unremitting realism divulges a body that does not conform to feminine notions of beauty—her breasts sag, her ample thighs are heavy and pendulous, and her distended stomach has lost its tone. Neel subjected herself to the same clinical analysis that she gave others. Her candor inevitably brings a shock of recognition to those who have passed the half-century mark.

This was not Neel's first self-portrait. This painting, however, has little in common with the small, self-effacing sketches she made of herself in the late 1920s and early 1930s [fig. 21]. No longer is Alice schoolgirl-like, overwhelmed by mother-

hood, or merely a sexual being with no other ostensible persona. Here she is a woman wholly comfortable with herself. A symphony of dashing color washes over her face as Neel, without apology, acknowledges her pride in her role as an artist and in her inherently lively character—not in her diminished physical state. In this audacious and memorable image, Neel reminds women of any age that the important thing is not how old you are, for that is transient, but how interesting you are.

Figure 21 **Alice by Alice**, 1932.
Pencil on paper. 12 × 8 in. (30.5 × 20.3 cm.)

NOTES

1. Hubert Crehan, "Introducing the Portraits of Alice Neel," *ArtNews* 61 (October 1962): 47; Cindy Nemser, "Alice Neel: Portraits of Four Decades," *Ms.* 2 (October 1973): 48; Alice Neel, *The Hasty Papers: A One-Shot Review,* ed. Alfred Leslie and Robert Frank (New York: Alfred Leslie, 1960), 50, quoted in Elke M. Solomon, *Alice Neel* (New York: Whitney Museum of American Art, 1974), n.p.

2. Patricia Hills, *Alice Neel* (New York: Harry N. Abrams, 1983; reprint, 1995), 134, 167. Neel's awareness of the way in which external attributes served as metaphors for the internal being of a sitter is apparent in her statement "I usually know why people look the way they look," quoted in Ann Sutherland Harris, *Alice Neel Paintings 1933–1982* (Los Angeles: Loyola Marymount University, 1983), 3.

3. Rita Mercedes, "The Connoisseur Interview: Alice Neel Talks with Rita Mercedes," *The Connoisseur* 208 (September 1981): 2. Neel, however, was equally proud of her visual recall. In Hills, *Alice Neel,* 77, Neel claims that an artist needs a good memory, whether or not the subject was beside the canvas, "because there are changes all the time. . . . You know what the Chinese say: 'You never bathe in the same water twice.'"

4. Hills, *Alice Neel,* 136.

5. Philip Pearlstein, Alex Katz, Andy Warhol, and Chuck Close are among the important post–World War II artists who have made portraiture a central part of their art. Focusing primarily on formal issues connected with likeness, none of these artists was concerned with the portrait as a psychological document. The sculptor George Segal comes closest to Neel's desire to explore the emotional aspects of human nature. For an overview of portraiture in the last half of the twentieth century, see Carolyn K. Carr and Ellen Miles, *A Brush with History: Paintings from the National Portrait Gallery* (Washington, D.C.: National Portrait Gallery, 2001), 56–59, ills. 63–76.

6. Cindy Nemser, "Alice Neel—Teller of Truth," in *Alice Neel: The Woman and her Work* (Athens: Georgia Museum of Art, 1975), n.p.

7. Hills, *Alice Neel,* 11.

8. Alice Neel, interview with Cindy Nemser, in *Art Talk: Conversations with Twelve Women Artists,* ed. Cindy Nemser (New York: Charles Scribners' Sons, 1975), 123.

9. Hills, *Alice Neel,* 167; Ellen H. Johnson, "Alice Neel's Fifty Years of Portrait Painting," *Studio International* 193, no. 987 (May–June 1977): 174.

10. Solomon, *Alice Neel,* n.p., noting this autobiographical connection in Neel's work, states "Critics writing about Alice Neel seem more interested in her personality than in her paintings. They speak of her wit, her biting candor and her sharp intelligence, but not as manifested in her work. Yet it is precisely Neel's ability to tell something both of herself and her sitter that distinguishes her as a portraitist within the academic tradition. To a lesser extent than Gertrude Stein, though similarly, Neel's biographies are autobiographical."

11. Hills, *Alice Neel,* 12; Harris, *Alice Neel Paintings,* 3.

12. Hills, *Alice Neel,* 13.

13. Isabetta remained with the Enríquez family in Cuba. She returned to the United States to visit Neel in 1934 and again in 1939. The two did not meet again until 1950. Isabetta died in 1982.

14. Pamela Allara, *Pictures of People: Alice Neel's American Portrait Gallery* (Hanover, New Hampshire: Brandeis University Press and the University Press of New England, 1998), 39, 50–51, 52–54; Ann Temkin, "Alice Neel: Self and Others," in *Alice Neel,* ed. Ann Temkin (Philadelphia: Philadelphia Museum of Art, 2000), 15, 17–18, provide an extended discussion of the symbolism of these two paintings. See also Jerry Saltz, "Painter Laureate: Alice Neel's Symbols," *Arts Magazine* 66 (November 1991): 25–26.

15. Hills, *Alice Neel,* 21, 23. In Nemser, "Alice Neel: Portraits," 125, Neel eloquently defined the crisis that confronts a female artist who is also a mother, stating "If you do [take ten years off], you lose your art. If you decide you are going to have children and give up painting during the time you have them, you give it up forever. Or if you don't, you just become a dilettante. It must be a continuous thing."

16. Hills, *Alice Neel,* 42.

17. Allara, *Pictures of People,* 31–32, 48–49, discusses various late-nineteenth-century and twentieth-century art that Neel referenced in her work, including the German Expressionists.

18. Manet's nudes of 1863 have been the subject of endless discussion. See for example, Theodore Reff, "The Meaning of Manet's Olympia," *Gazette des Beaux-Arts* ser. 6, vol. 63 (February 1964): 111–22; Ann Coffin Hanson, *Manet and the Modern Tradition* (New Haven: Yale University Press, 1975; reprint, 1979), 90–102; Eunice Lipton, "Manet: A Radicalized Female Imagery," *Artforum* 13 (March 1975): 48–53.

19. See Gerald L. Belcher and Margaret L. Belcher, *Collecting Souls, Gathering Dust: The Struggles of Two American Artists, Alice Neel and Rhoda Medary* (New York: Paragon House, 1991), 7–128. While both Neel and Medary were committed to their art as young women, Medary married, led a conventional life, and produced no significant art. Regrettably, Medary's history was a common one, particularly for women of her generation. Her history serves to underscore Neel's obsessive single-mindedness about her art. Neel's perseverance despite myriad obstacles was an important factor in the development of her iconic status in the 1970s.

20. Allara, *Pictures of People,* 220, places Neel's nudes within the pictorial traditions of the late nineteenth and twentieth centuries and also credits her with the invention of the nude portrait.

21. Richard Flood, "Gentleman Callers: Alice Neel and the Art World," in Temkin, *Alice Neel,* 61; Cindy Nemser and John Perreault, quoted in Ann Temkin, "Undergoing Scrutiny: Sitting for Alice Neel," in *Alice Neel,* 68–69. In their interviews with Temkin, Cindy Nemser and John Perreault talk about the verbal exchange with Neel that led them to pose nude. Robert Stewart, whose portrait is now in the collection of the National Portrait Gallery, told the author in a 1984 conversation that Neel had asked him to pose nude, but he

had refused. Artist Faith Ringgold told art critic Edward J. Sozanski, in "Sitting for Alice," *Philadelphia Inquirer,* 25 June 2000, sec. I, p. 13, that Neel had asked her to pose nude, but she had refused. In retrospect, she admitted, she wished that she had acceded to Neel's request.

22. Hills, *Alice Neel,* 56.

23. In the spring and fall of 1932, Neel participated in both the first and second Washington Square Outdoor Art Exhibitions. The following year she participated in several group shows, including one at the Mellon Galleries in Philadelphia and two organized by the Artists' Aid Committee. In 1936 and 1939, Neel showed in the first and second exhibitions of the American Artists' Congress at the A. C. A. Galleries, and in 1938 sixteen works constituted her first solo exhibition at the Contemporary Arts Gallery at 38 West 57th Street. The *Philadelphia Inquirer* noted that she was a former Philadelphian and said of her work that "There is nothing pretty about these pictures, but they have substance and honesty." "'Living Art' from America and Europe at the Mellon Galleries," *Philadelphia Inquirer,* 19 March 1933, quoted in Temkin, *Alice Neel,* 163–167, 188.

24. Temkin, *Alice Neel,* 164–67.

25. Multiple possibilities are plausible explanations for this imbalance. When Doolittle destroyed her work, a disproportionate number of these paintings and watercolors could have been portraits of women. The WPA favored "New York type scenes," and this may have encouraged Neel's interest in urban vistas. It is also possible that Neel submitted portraits of women that were then either dispersed or destroyed by the agency. Neel's unsettled personal life and multiple moves may have diminished the opportunities for casual neighborhood friendships, which, in the 1940s, were the impetus for numerous portraits. Moreover, men dominated her life in the 1930s, whether as friends, romantic partners, or intellectual companions, a fact evidenced by the substantial number of male portraits done during this decade, particularly of men who shared her interest in the Communist Party.

26. Nemser, "Alice Neel: Portraits," 137.

27. Nemser, "Alice Neel: Portraits," 124. The mother's husband is the subject of the painting *T. B. Harlem* (1940; Washington, D.C., The National Museum of Women in the Arts).

28. Allara, *Pictures of People,* 281, n. 54, gives a brief summary of her relationship with this formidable figure.

29. Allara, *Pictures of People,* 163–64.

30. Neel painted four portraits of her mother, in 1935, 1946, 1952, and 1953. The second was completed not long after Neel's father's death, when he was eighty-two, in May 1946.

31. Hubert Crehan, "Portraits of Alice Neel," 44–47, 68.

32. Temkin, *Alice Neel,* 169–71, 188. Exhibitions at Reed College, Dartmouth College, Fordham University, the Maxwell Galleries in San Francisco, and the Nightingale Gallery in Toronto suggest the steady expansion of Neel's reputation beyond New York during the 1960s.

33. Nancy Neel, quoted in Temkin, "Sitting for Alice Neel," in *Alice Neel,* 73–74.

34. Johnson, "Neel's Fifty Years of Portrait Painting," 175.

35. All social change is evolutionary, but many mark the advent of a new cohesion and visibility among feminists in the art world to the article by Linda Nochlin, "Why Have There Been No Great Women Artists?," *ArtNews* 69 (January 1971): 29–39ff. Paul Richard, "Appreciation: Alice Neel, Painting's Piercing Soul," *Washington Post,* 16 October 1984, sec. B, p. 4, notes her role as a source of inspiration for feminist artists.

36. The exhibition chronology and bibliography in Temkin, *Alice Neel,* 188–96, vividly demonstrates the increased interest in Neel's work from 1970 until her death.

37. Other portraits of couples painted during the last two decades of her life include *Ian and Mary* (1971), *Benny and Mary Ellen Andrews* (1972), and *Georgie and Annemarie* (1982). Portraits of families, like *The Family (John Gruen, Jane Wilson, and Julia)* (1970) and *The Robinson Family* (1974) also found a place in her oeuvre.

38. Ted Castle, "Alice Neel," *Artforum* 22 (October 1983): 37.

39. Cindy Nemser talks about sitting for Neel in Temkin, "Sitting for Alice Neel," in *Alice Neel,* 68–69.

40. Grooms quoted in Richard, "Painting's Piercing Soul," sec. B, pp. 1, 4.

41. John Perreault, quoted in Temkin, "Sitting for Alice Neel," in *Alice Neel,* 71.

42. Neel was not the first female artist to paint herself nude. French artist Suzanne Valedon painted a nude *Self Portrait* (1931; Paris, Private collection) as did Frida Kahlo, who depicted herself both nude and pregnant in *Henry Ford Hospital* (1932; Mexico City, Dolores Olmedo Collection). However, among the elements that distinguish Neel's portrait from these earlier works are its size and scale as well as the confident, insistent manner in which the artist confronts the viewer.

Mother and Child

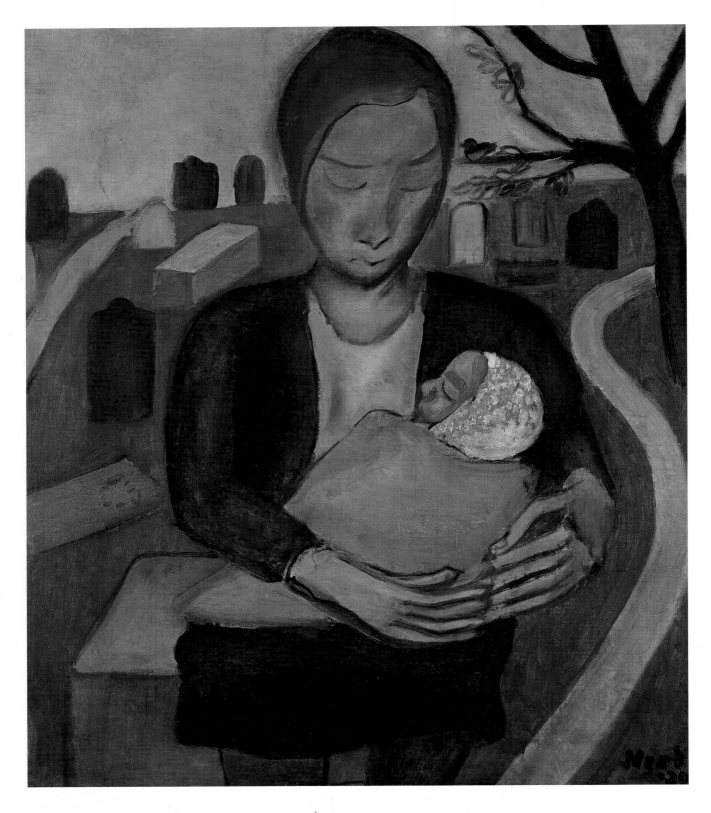

Plate 1
Mother and Child
1930. Oil on canvas. 26 × 22 in. (66 × 55.9 cm.)

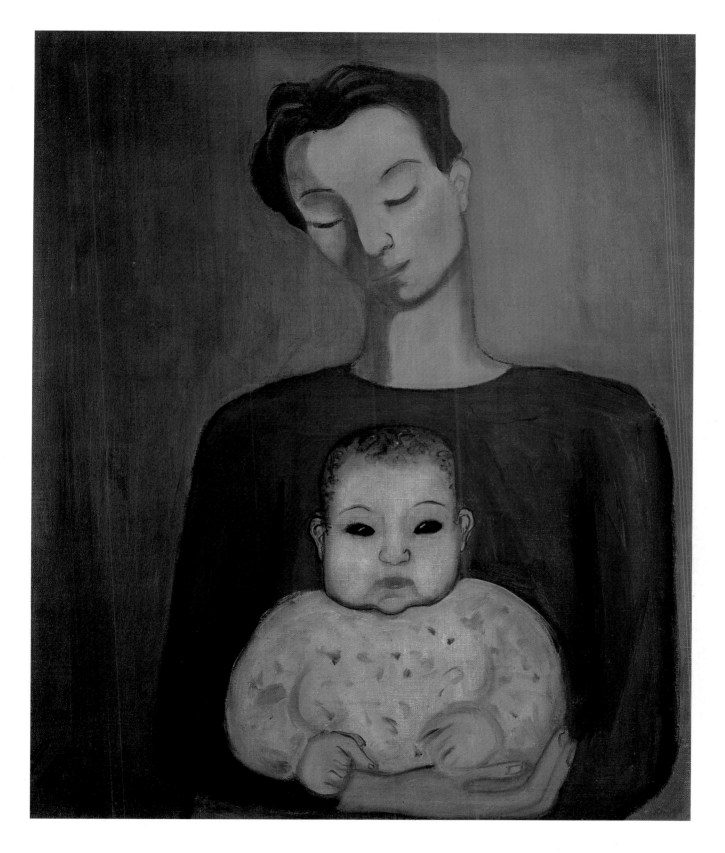

Plate 2
Mother and Child
1930. Oil on canvas. 28 × 23 in. (71.1 × 58.4 cm.)

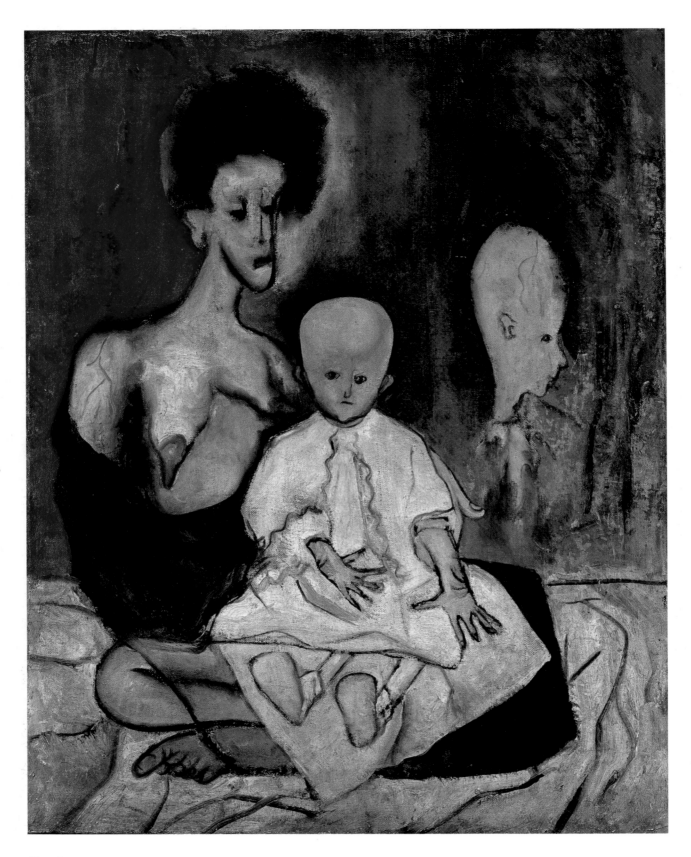

Plate 3
Degenerate Madonna
1930. Oil on canvas. 31 × 24 in. (78.7 × 61 cm.)

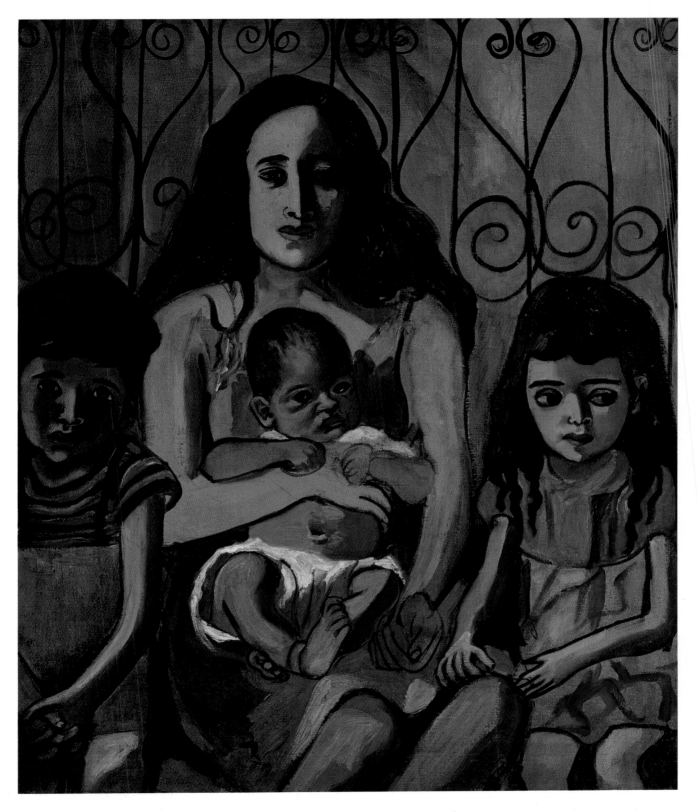

Plate 4
The Spanish Family
1943. Oil on canvas. 34 × 28 in. (86.4 × 71.1 cm.)

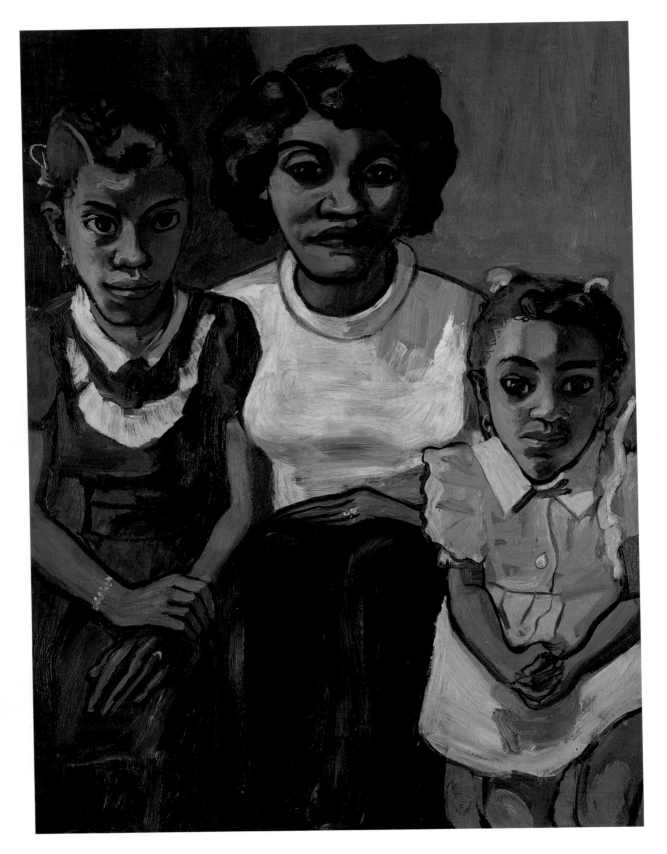

Plate 5
Black Spanish-American Family
1950. Oil on board. 30 × 22 in. (76.2 × 55.9 cm.)

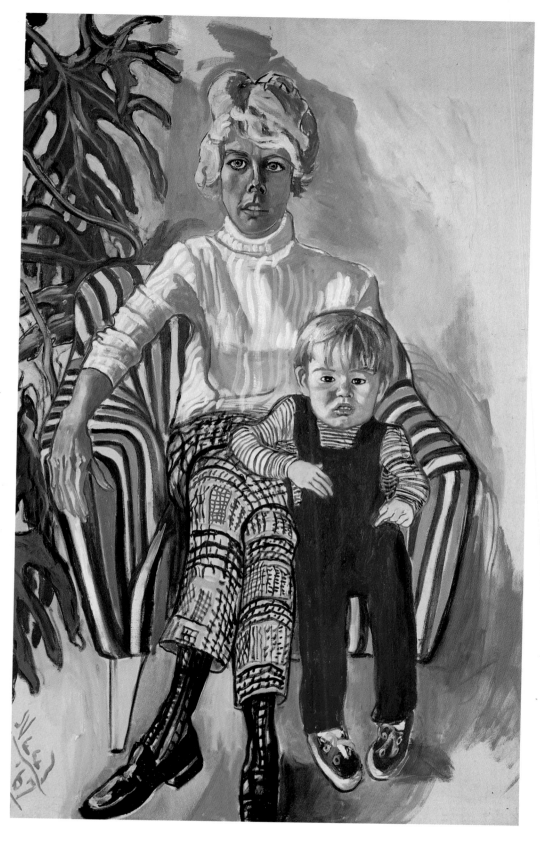

Plate 6
Mrs. Paul Gardner and Sam
1967. Oil on canvas. 56 × 35 in. (142.2 × 88.9 cm.)

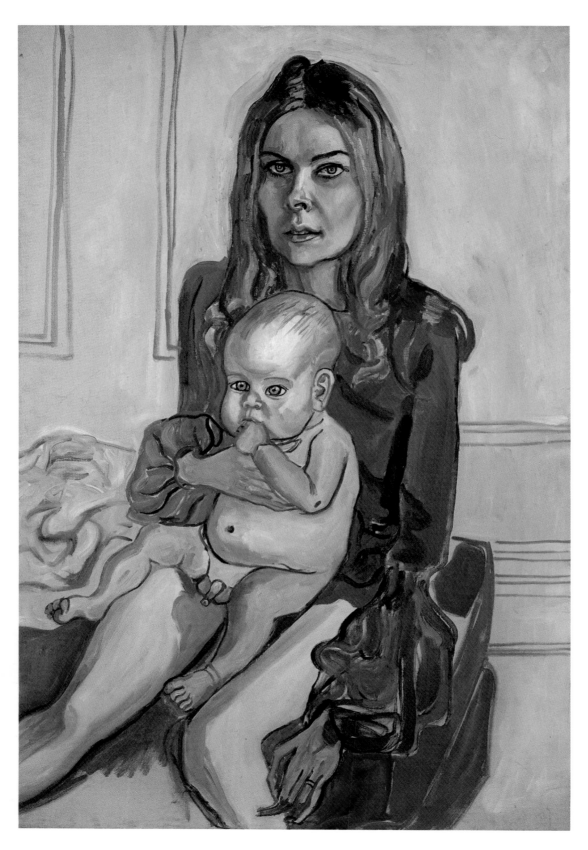

Plate 7
Betty Homitzky and Jevin
1968. Oil on canvas. 48 × 32 in. (121.9 × 81.2 cm.)

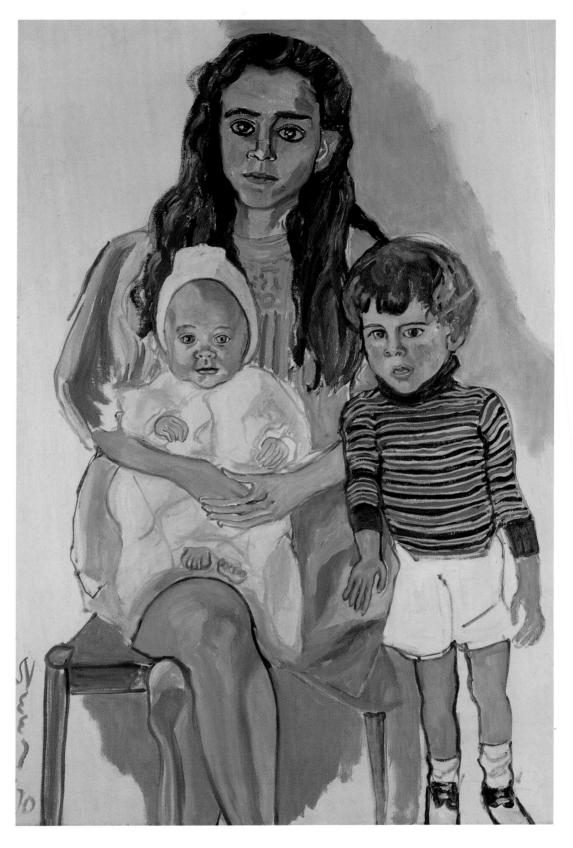

Plate 8
Julie and Children
1970. Oil on canvas. 45 7/8 × 29 3/4 in. (116.5 × 75.6 cm.)

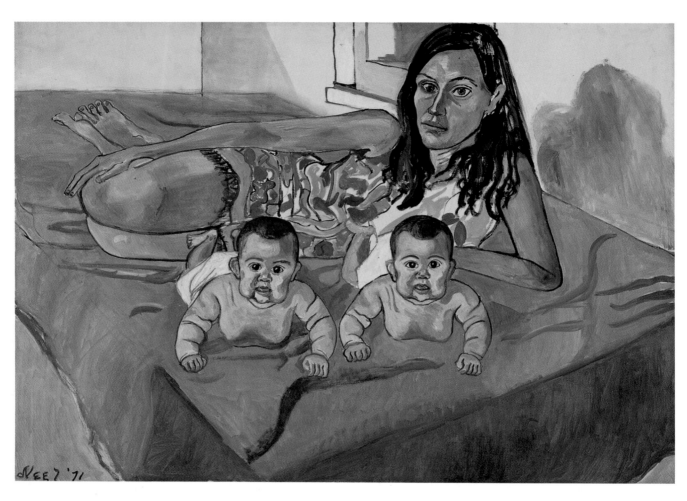

Plate 9
Nancy and Twins, Five Months
1971. Oil on canvas. 44 × 60 in. (111.8 × 152.4 cm.)

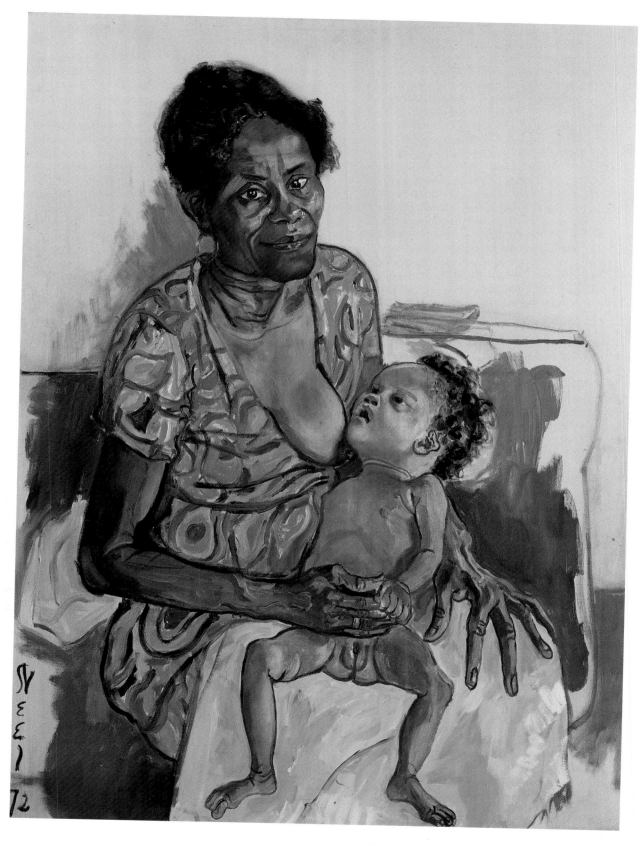

Plate 10
Carmen and Judy
1972. Oil on canvas. 40 × 30 in. (101.6 × 76.2 cm.)

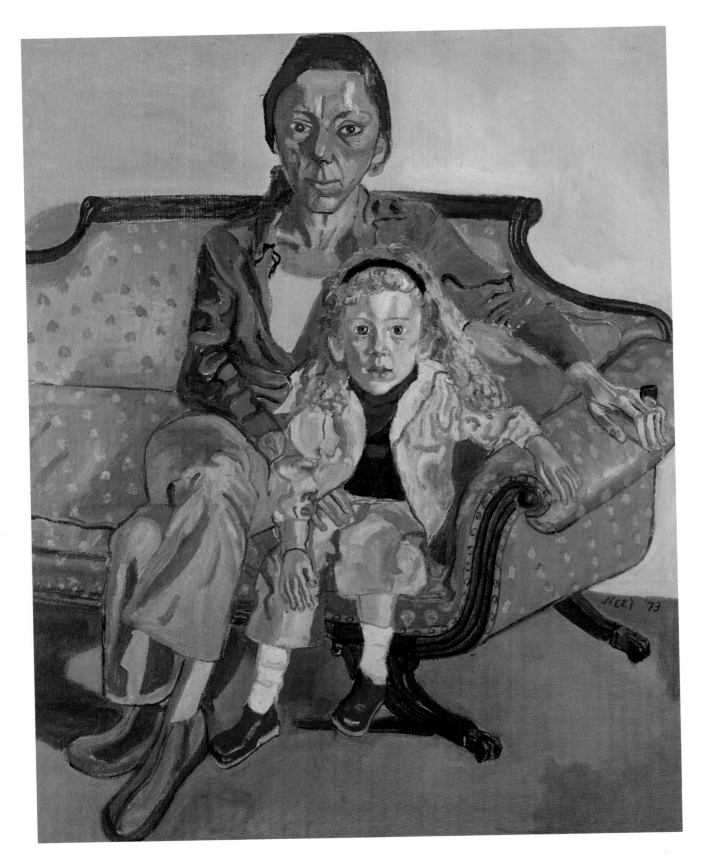

Plate 11
Linda Nochlin and Daisy
1973. Oil on canvas. 55 1/2 × 44 in. (141 × 111.8 cm.)

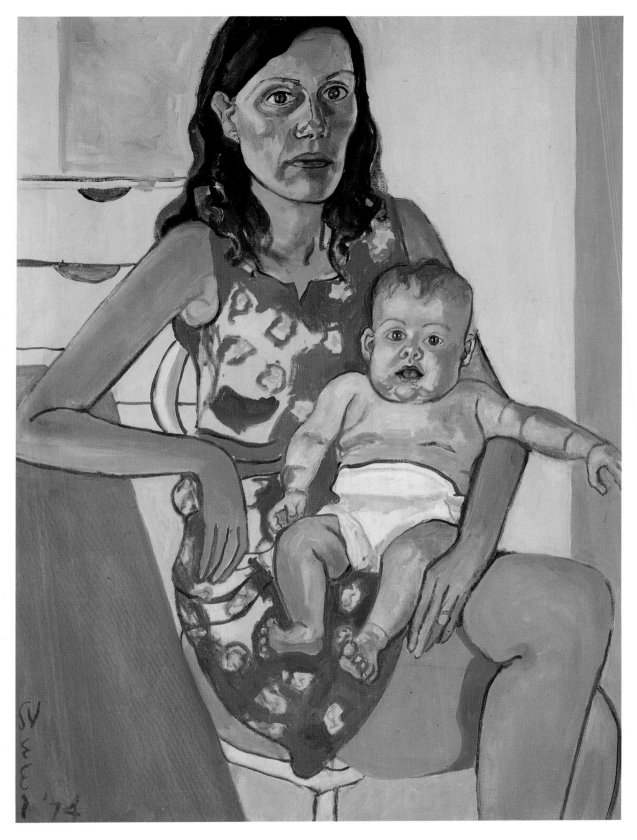

Plate 12
Nancy and Victoria
1974. Oil on canvas. 40 × 30 in. (101.6 × 76.2 cm.)

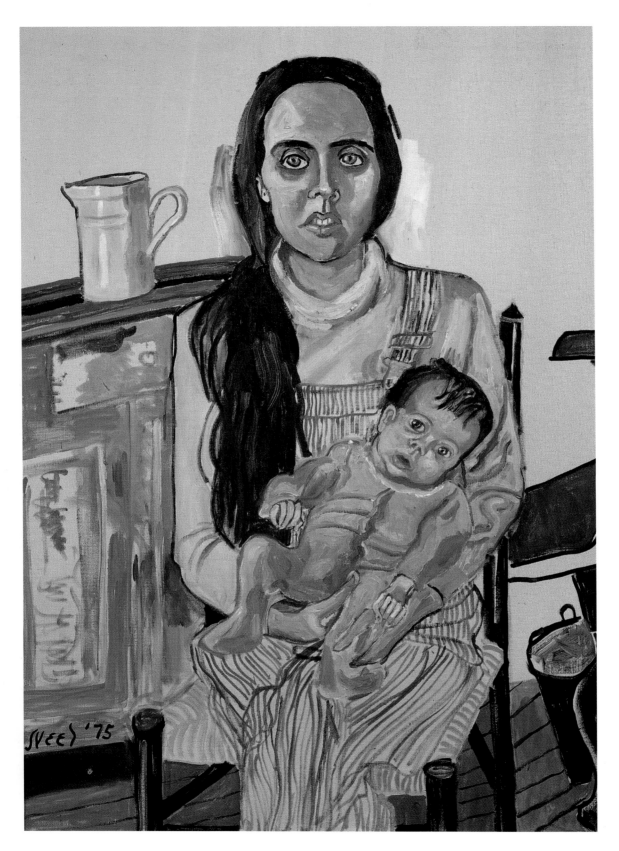

Plate 13
Ginny and Elizabeth
1975. Oil on canvas. 42 × 30 in. (106.7 × 76.2 cm.)

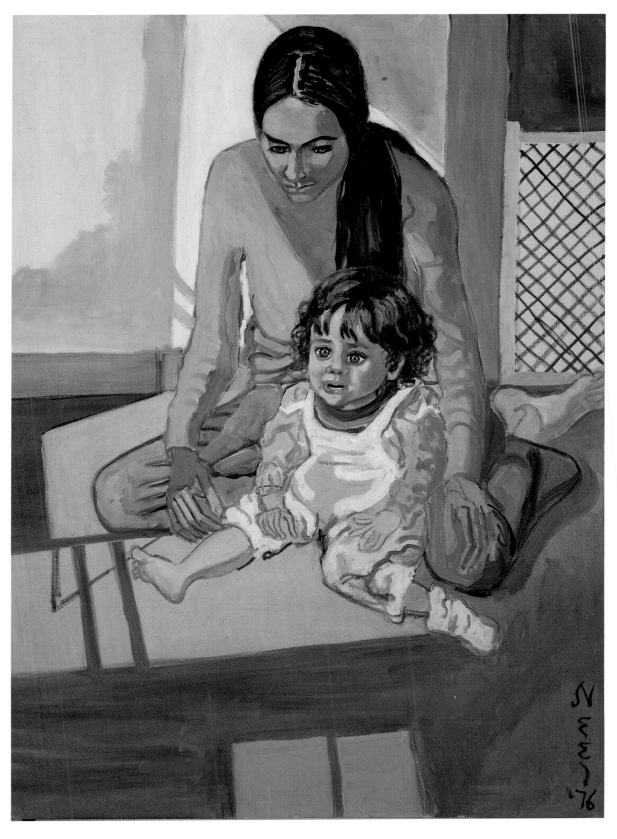

Plate 14
Ginny and Elizabeth
1976. Oil on canvas. 44 × 32 in. (111.8 × 81.3 cm.)

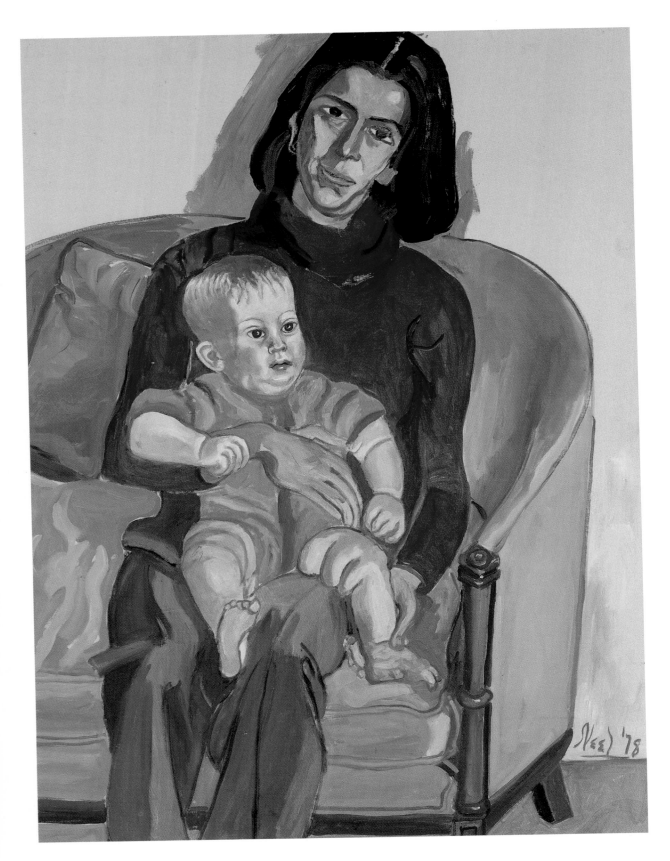

Plate 15
Ann Sutherland Harris and Neil
1978. Oil on canvas. 49½ × 30 in. (125.7 × 76.2 cm.)

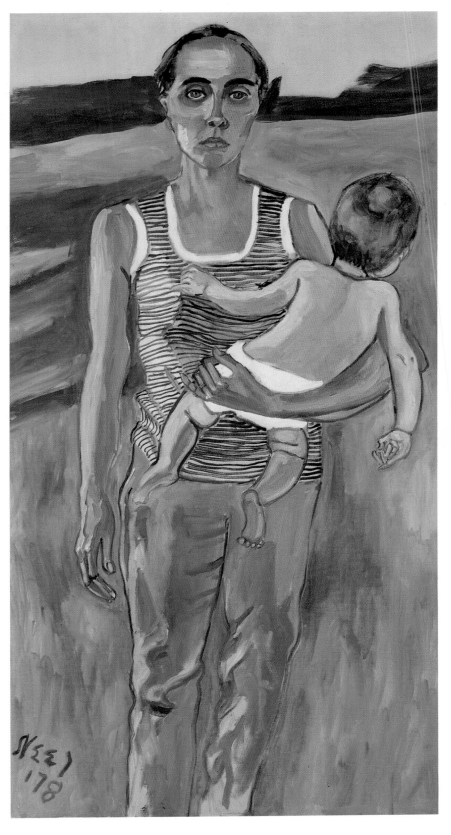

Plate 16
Ginny and Andrew
1978. Oil on canvas. 48¼ × 25⅛ in. (122.6 × 63.8 cm.)

Gesture

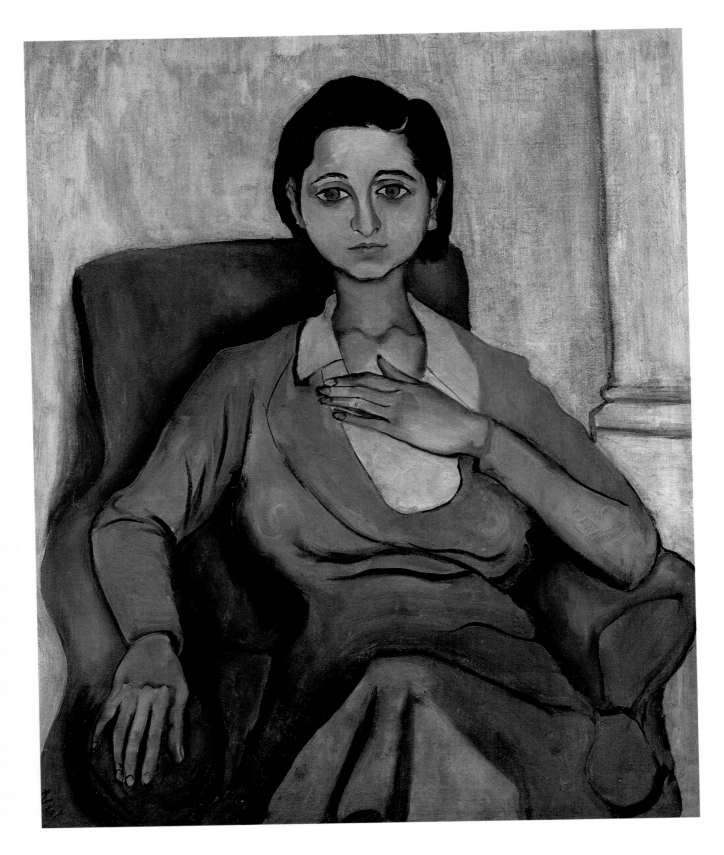

Plate 17
Fanya
1930. Oil on canvas. 32 × 26 in. (81.3 × 66 cm.)

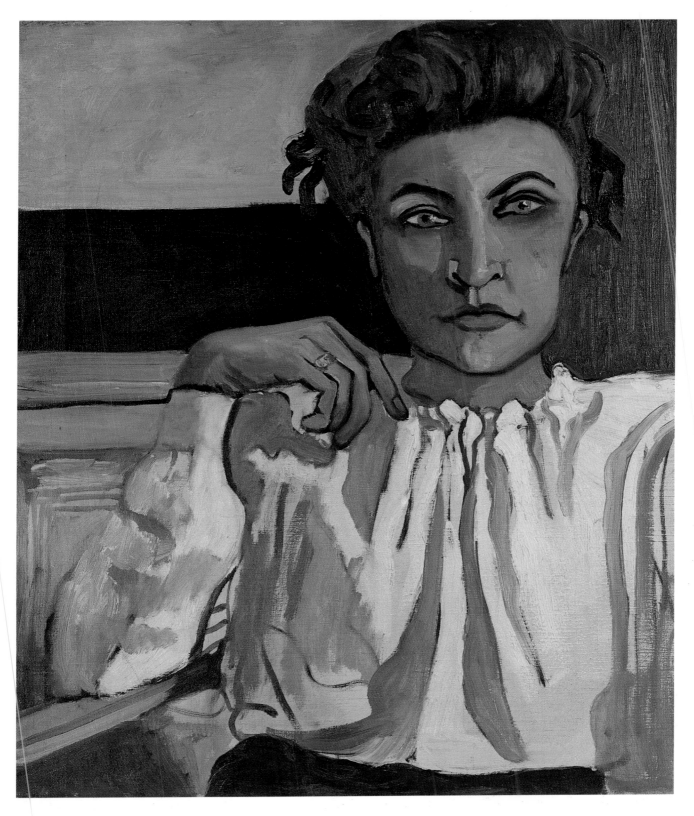

Plate 18
Elenka
1936. Oil on canvas. 24 × 20 in. (61 × 50.8 cm.)

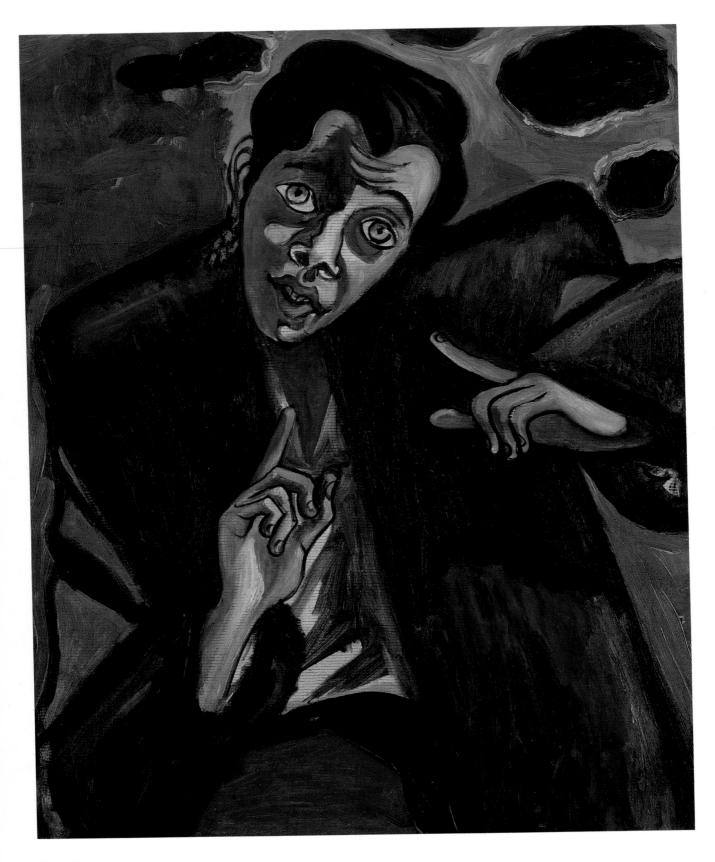

Plate 19
Bessie Boris
1940. Oil on board. 23 × 18 in. (58.4 × 45.7 cm.)

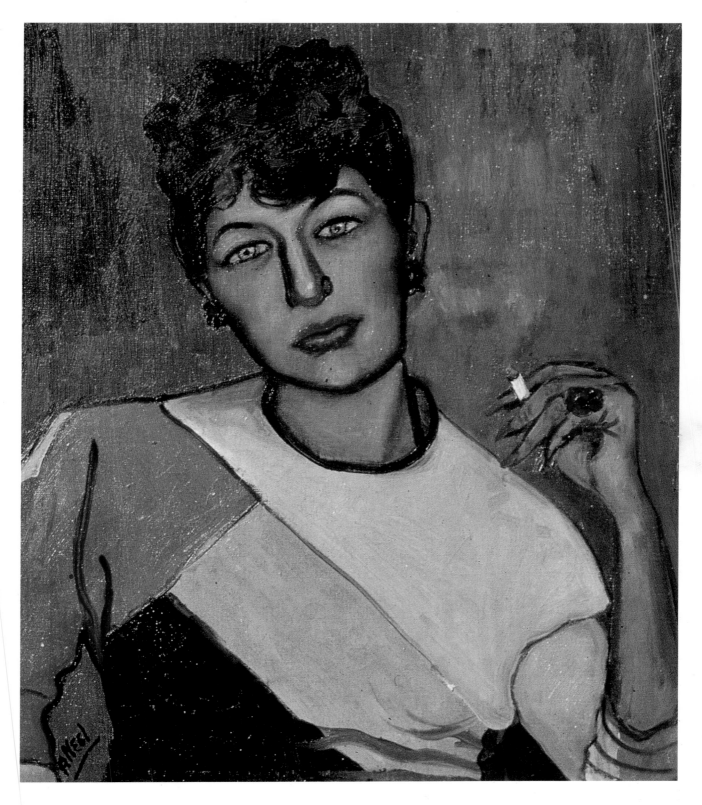

Plate 20
Art Dealer
1942. Oil on canvas. 23 × 20 in. (58.4 × 50.8 cm.)

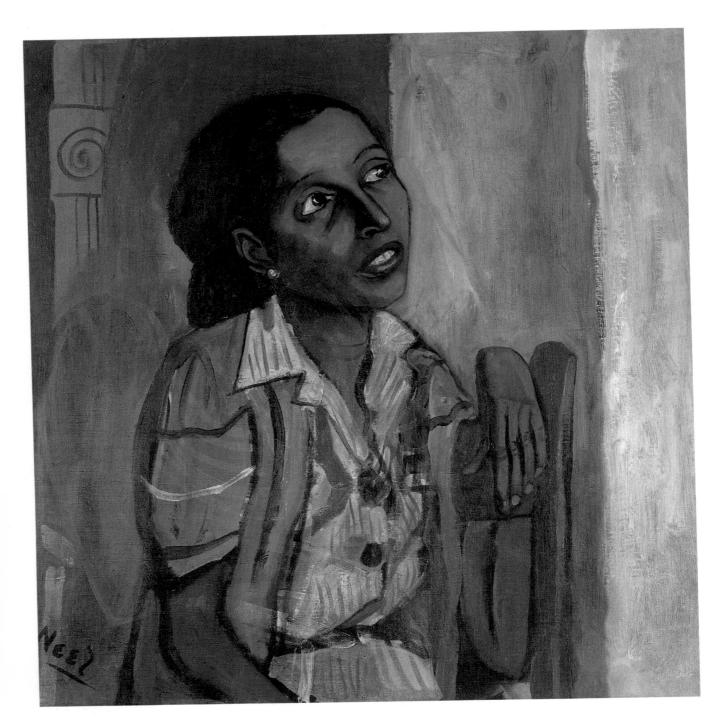

Plate 21
Mercedes Arroyo
1952. Oil on canvas. 25 × 24⅛ in. (63.5 × 61.3 cm.)

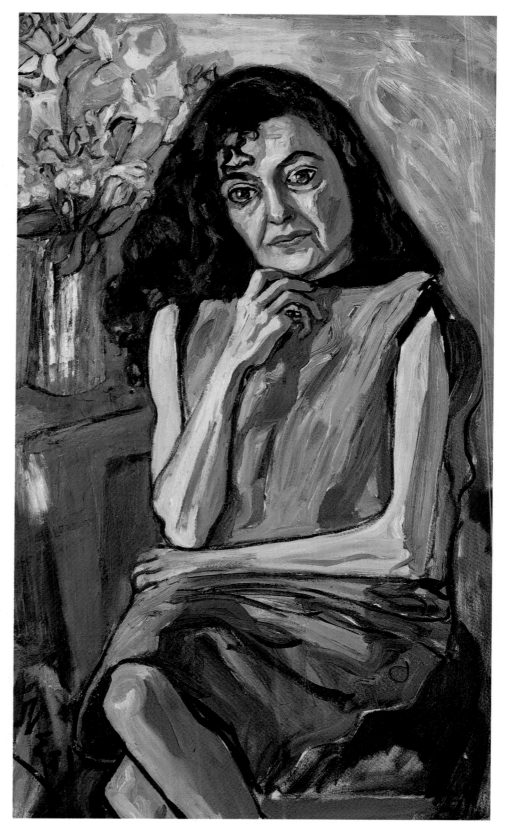

Plate 22
Spanish Woman
c. 1950. Oil on canvas. 38 × 22 in. (96.5 × 55.9 cm.)

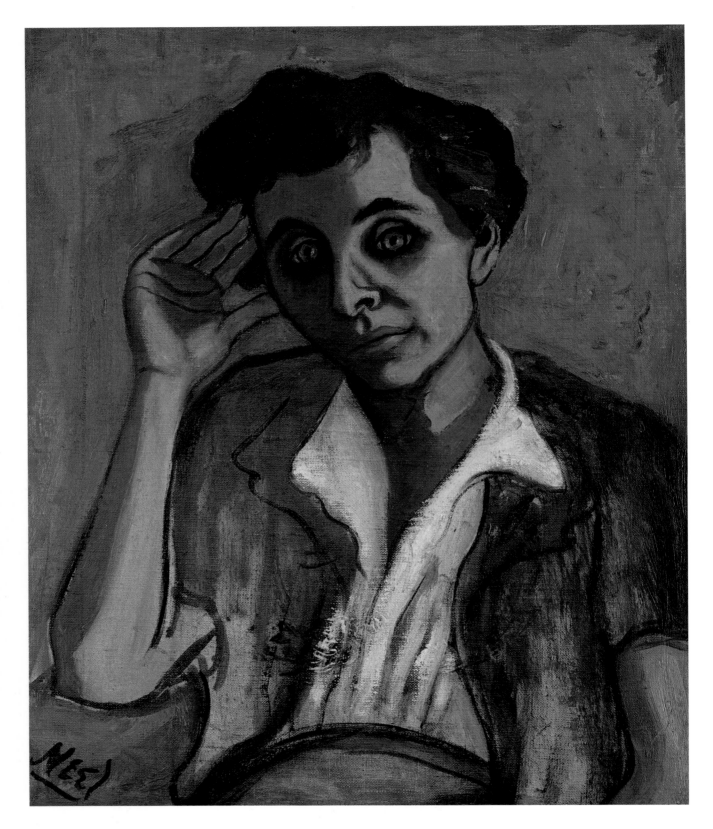

Plate 23
Sarah Shiller
1952. Oil on canvas. 22 × 18 in. (55.9 × 45.7 cm.)

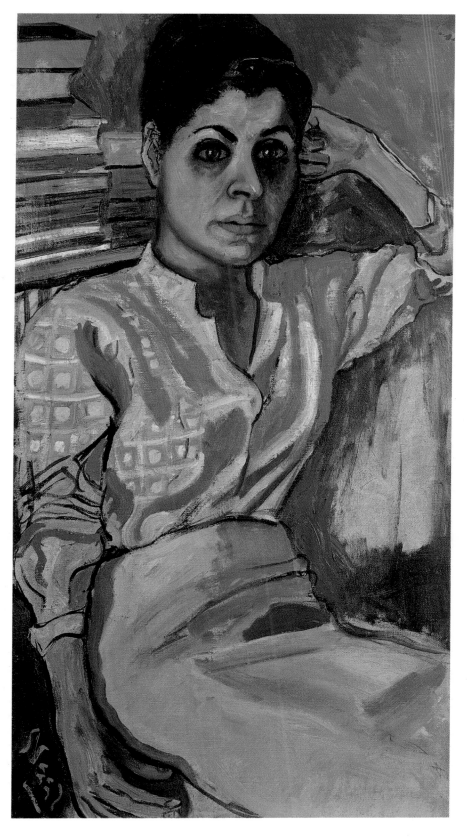

Plate 24
Mimi
1955. Oil on canvas. 32 × 17 in. (81.3 × 43.2 cm.)

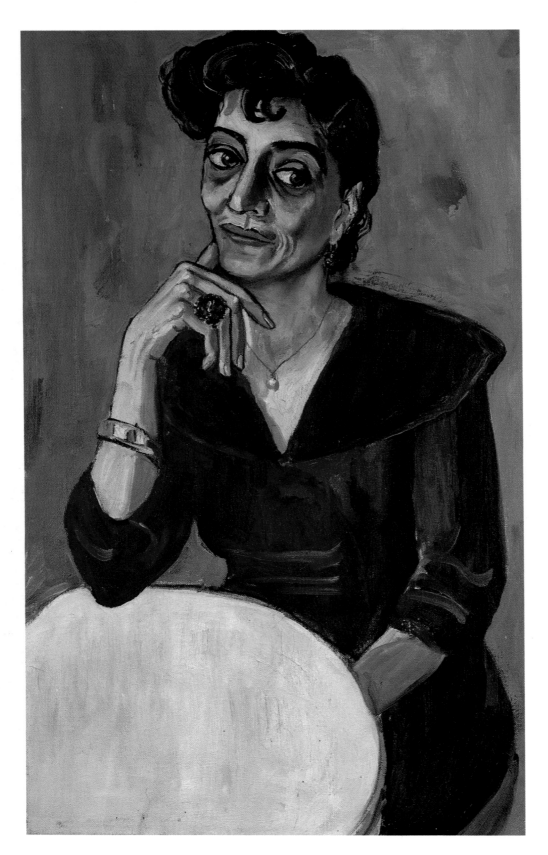

Plate 25
Elsie Rubin
1958. Oil on canvas. 30 × 18 in. (76.2 × 45.7 cm.)

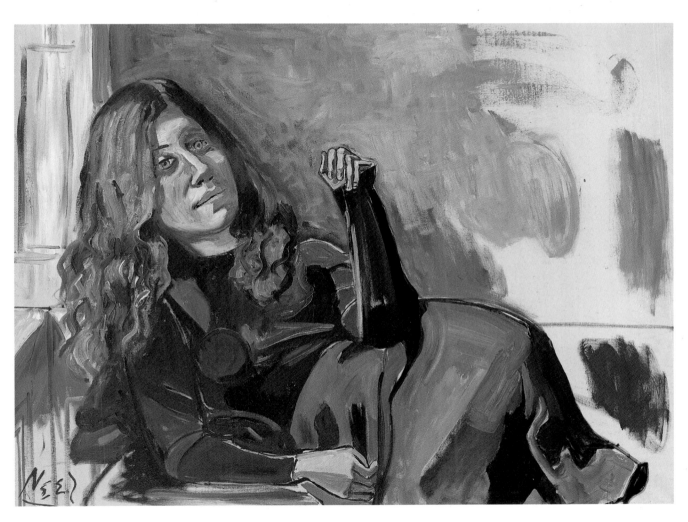

Plate 26
Suzanne Moss
1962. Oil on canvas. 34¼ × 44⅛ in. (87 × 112 cm.)

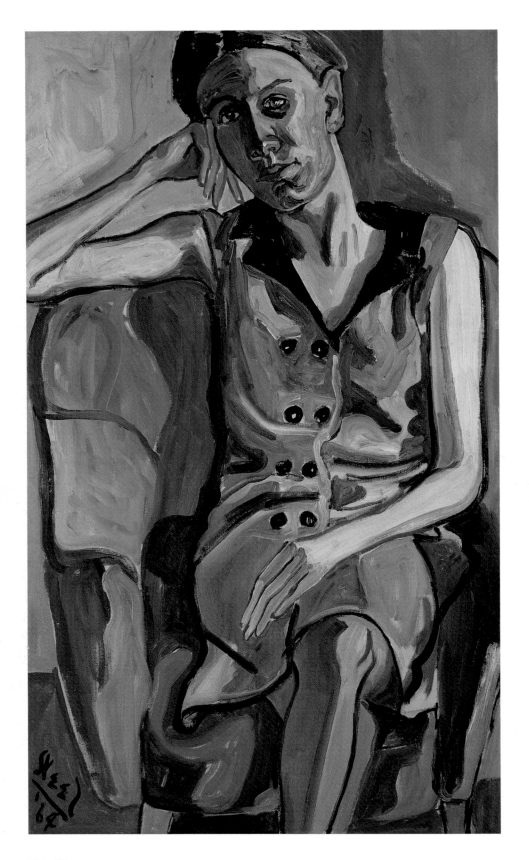

Plate 27
Eka
1964. Oil on canvas. 38 × 22 in. (96.5 × 55.9 cm.)

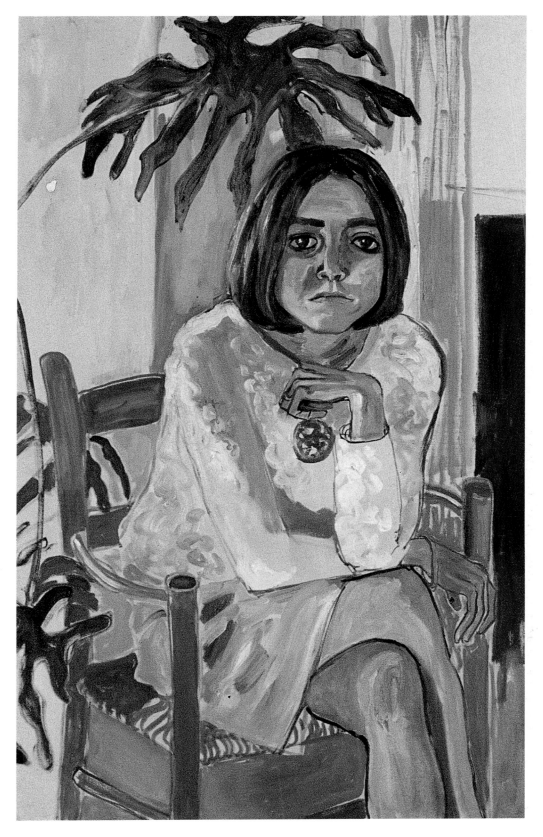

Plate 28
Julie Hall
1964. Oil on canvas. 46 × 30 in. (116.8 × 76.2 cm.)

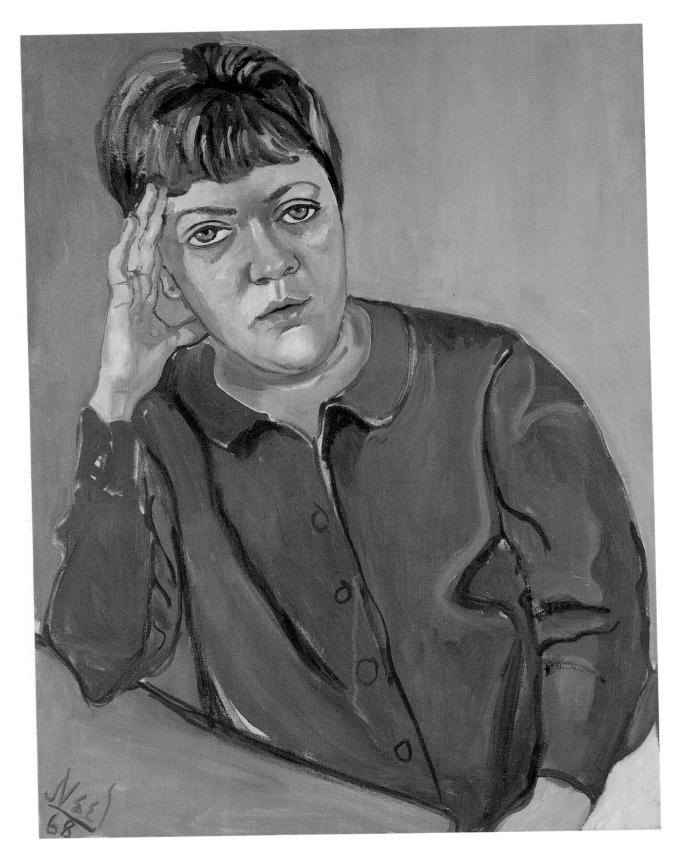

Plate 29
New Jersey Bride
1968. Oil on canvas. 29 × 22 in. (73.7 × 55.9 cm.)

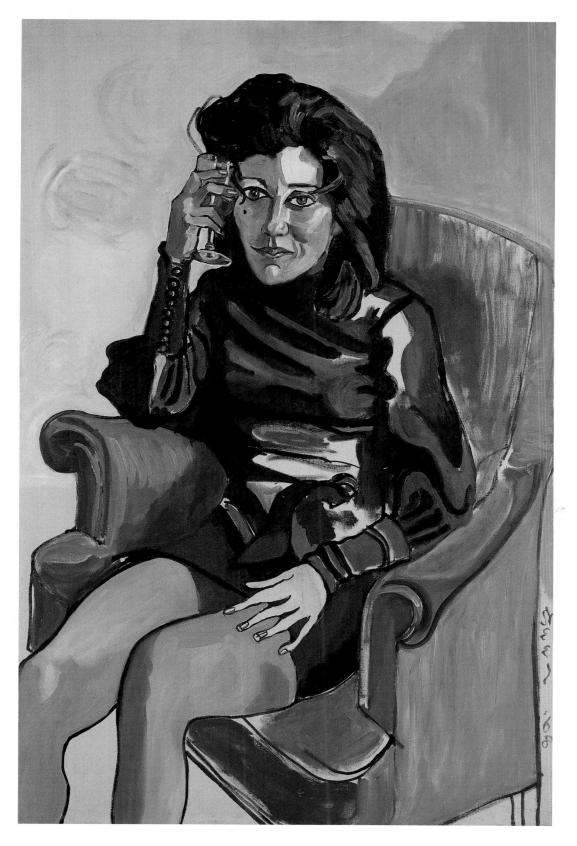

Plate 30
Marilyn Rabinowich
1968. Oil on canvas. 46 × 30 in. (116.8 × 76.2 cm.)

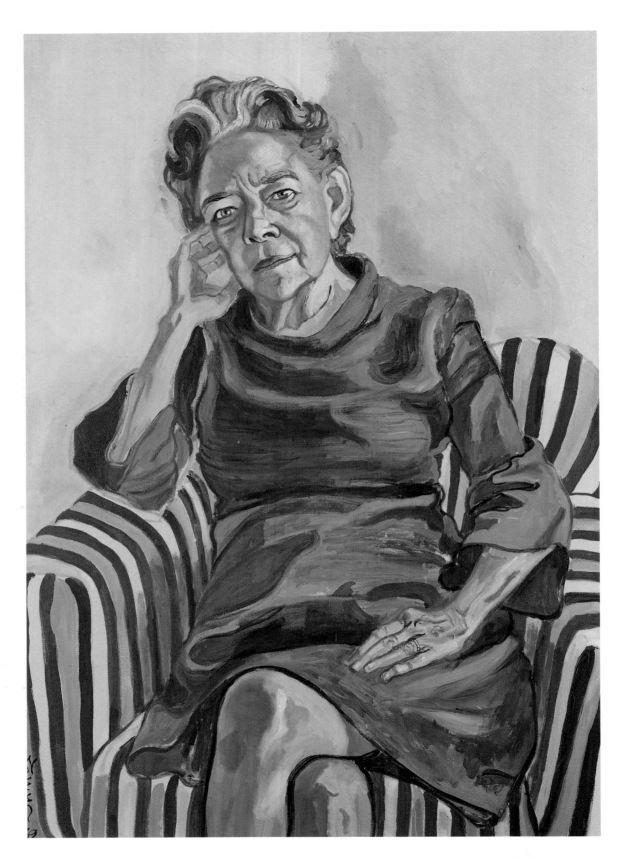

Plate 31
Helen Merrell Lynd
1969. Oil on canvas. 44 × 30 in. (112 × 76 cm.)

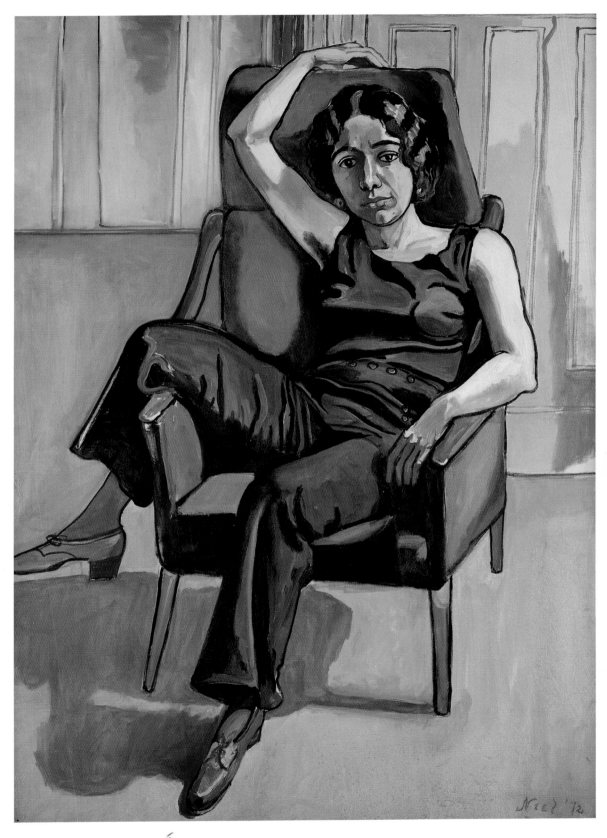

Plate 32
Marxist Girl (Irene Peslikis)
1972. Oil on canvas. 59¾ × 42 in. (151.8 × 106.7 cm.)

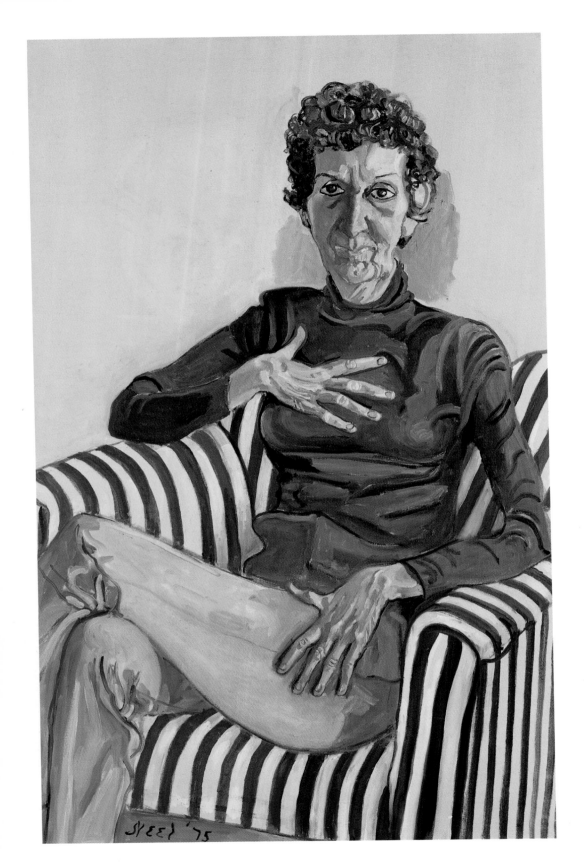

Plate 33
Dorothy Gillespie
1975. Oil on canvas. 48 × 30 in. (121.9 × 76.2 cm.)

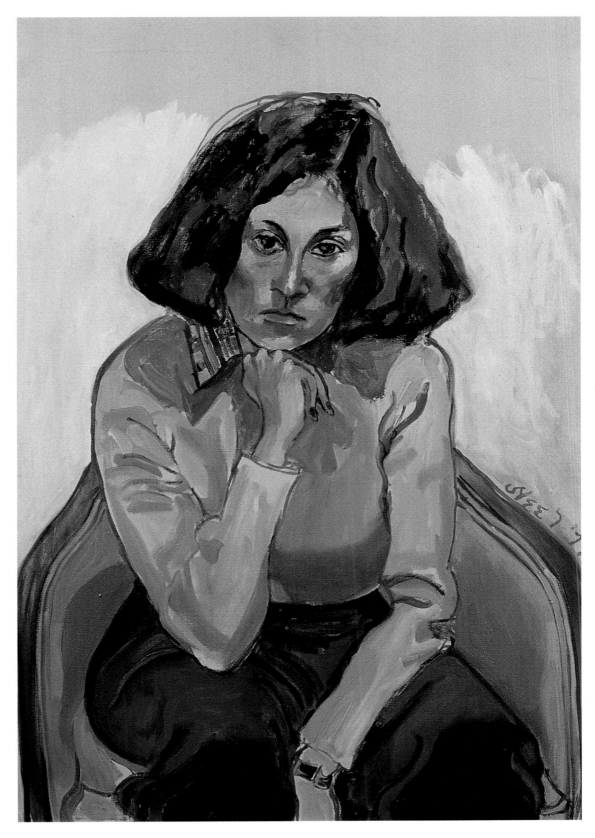

Plate 34
Marilyn Farber
1977. Oil on canvas. 40 × 30 in. (101.6 × 76.2 cm.)

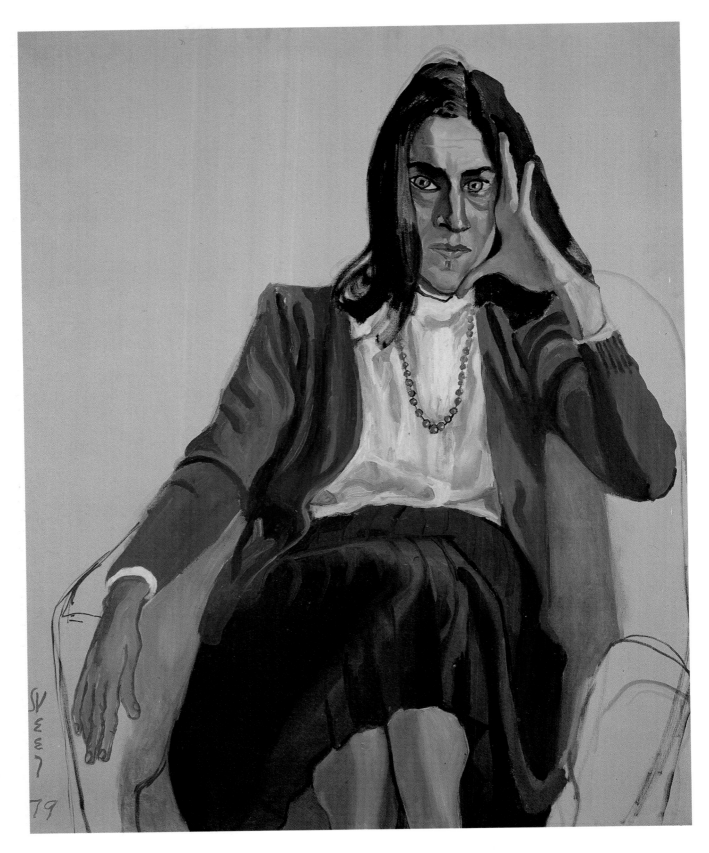

Plate 35
Betsy
1979. Oil on canvas. 42 × 34 in. (106.7 × 86.4 cm.)

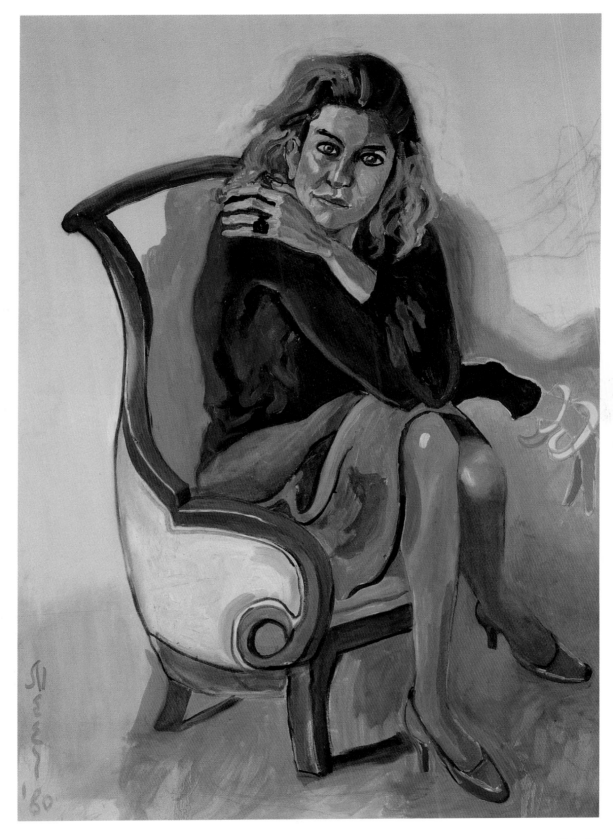

Plate 36
Toni Schulman
1980. Oil on canvas. 46 × 30 in. (116.8 × 76.2 cm.)

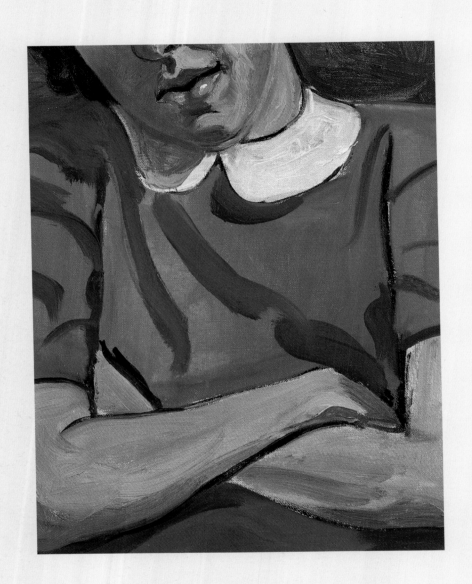

Pose

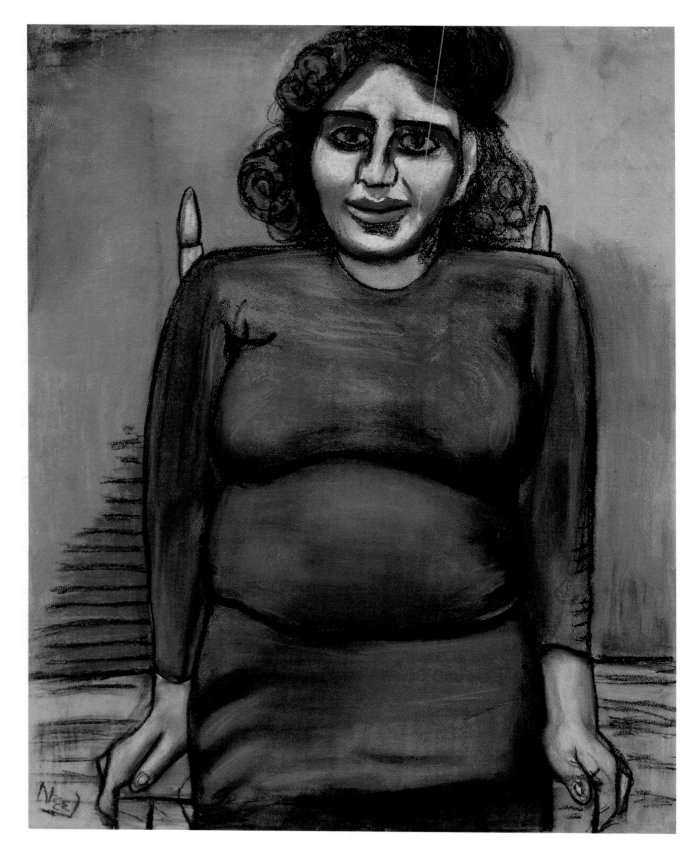

Plate 37
Blanche Angel, Pregnant
1937. Pastel on paper. 26 × 20⁹/₁₆ in. (66 × 52.2 cm.)

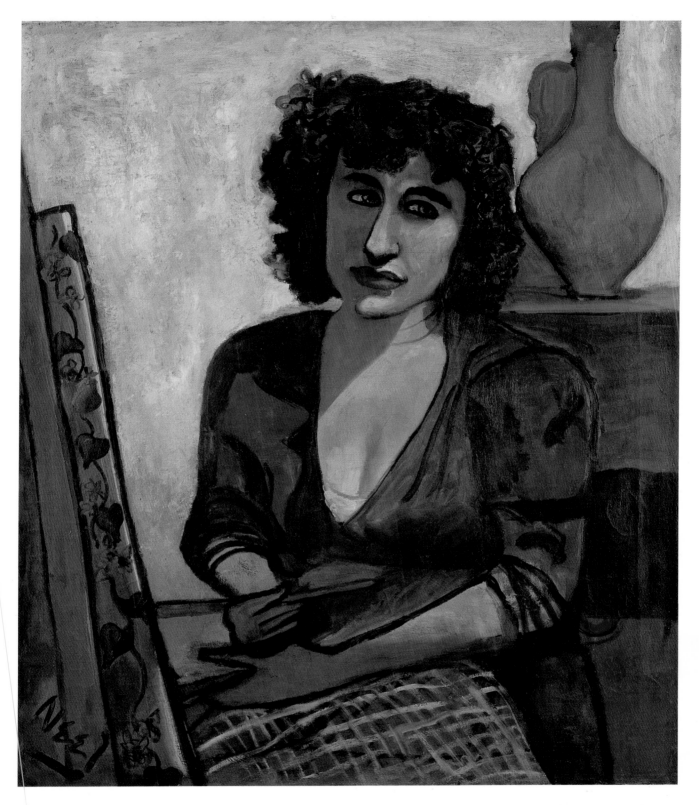

Plate 38
Dorothy Koppelman
1944. Oil on canvas. 30 × 25 in. (76.2 × 63.5 cm.)

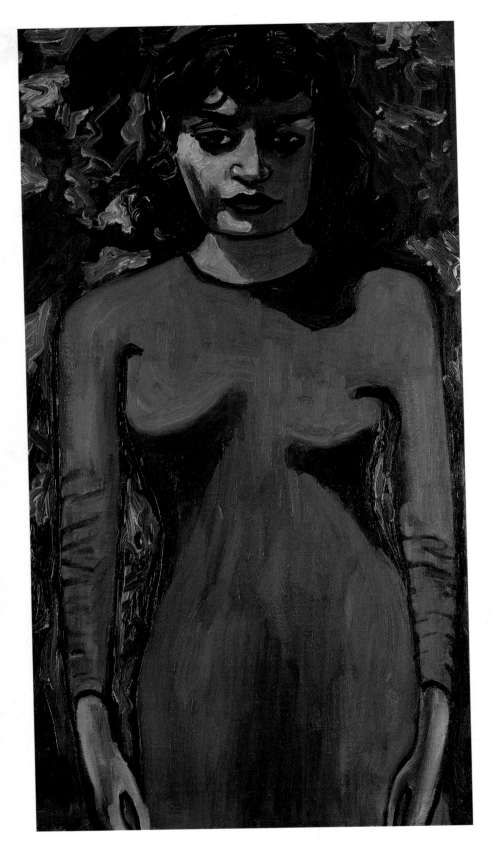

Plate 39
Dick Bagley's Girlfriend
1946. Oil on canvas. 30 × 16 in. (76.2 × 40.6 cm.)

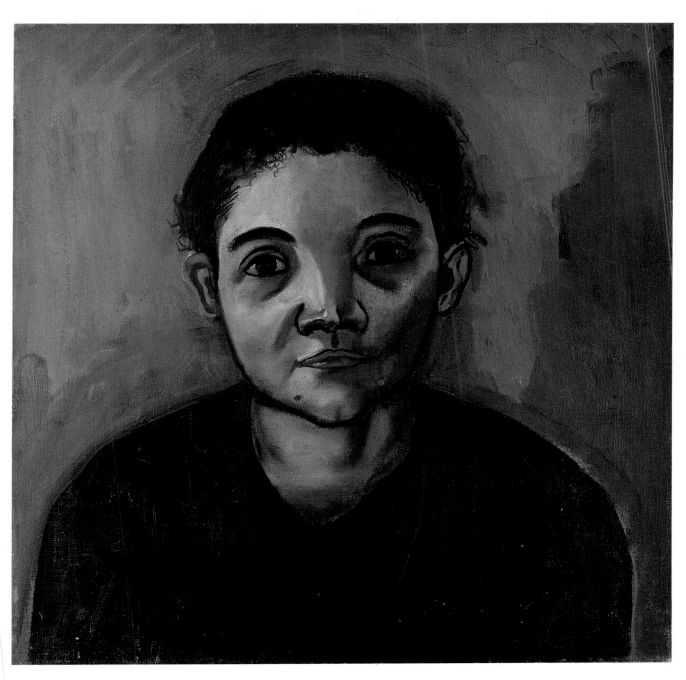

Plate 40
Josephine Garwood
1946. Oil on canvas. 18 × 18 in. (45.7 × 45.7 cm.)

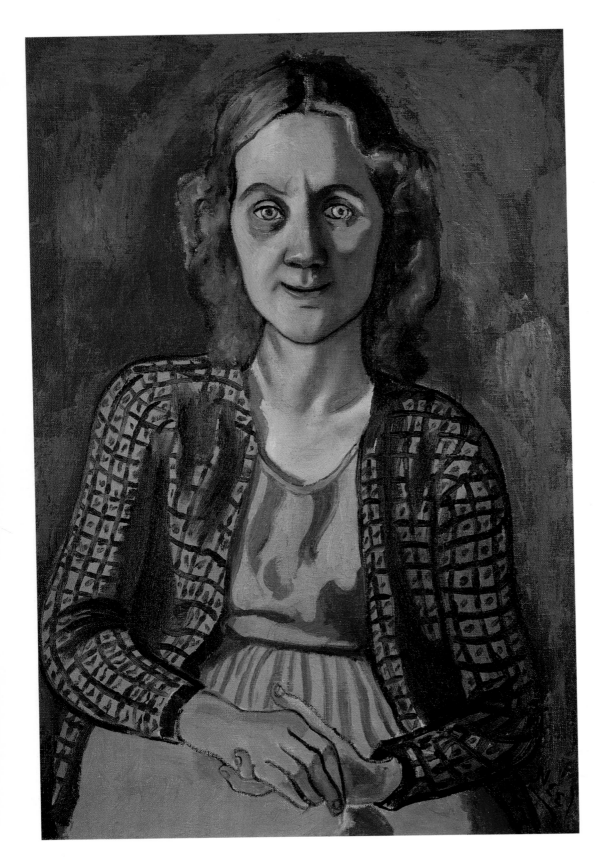

Plate 41
Beulah Heibel
1947. Oil on canvas. 30⅛ × 20⅛ in. (76.5 × 51.1 cm.)

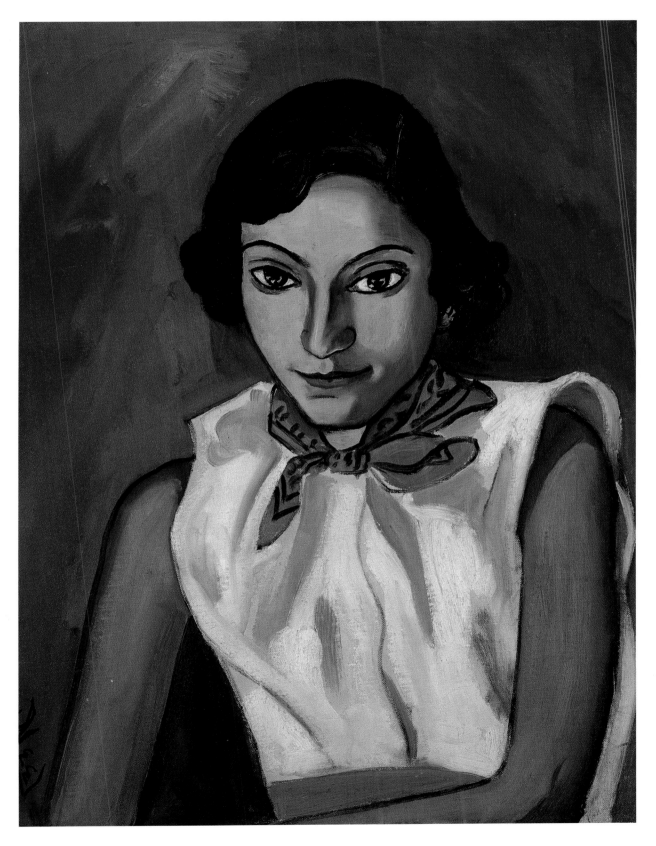

Plate 42
Mady
1949. Oil on canvas board. 23⅞ × 18 in. (60.6 × 45.7 cm.)

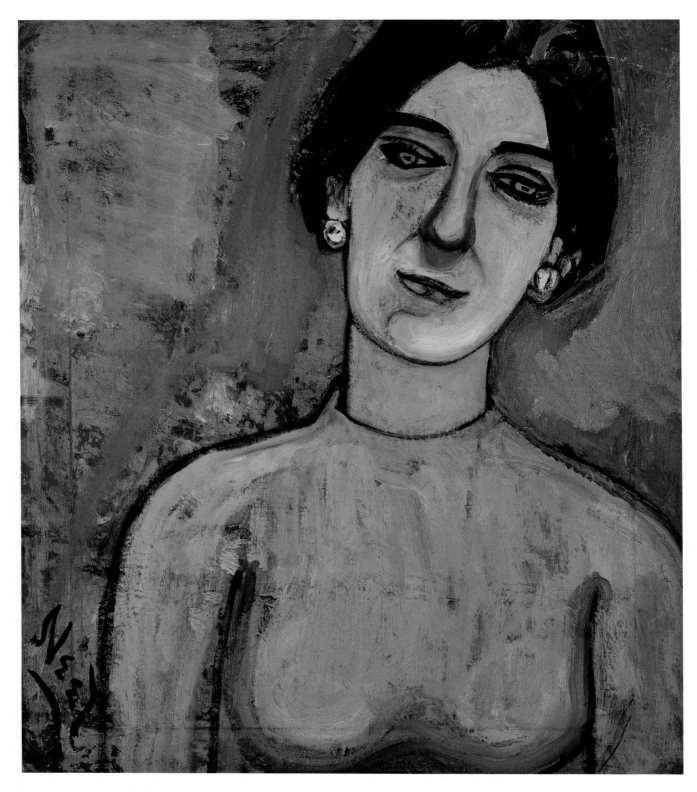

Plate 43

Dore Ashton

1952. Oil on canvas. 24 × 20 in. (61 × 50.8 cm.)

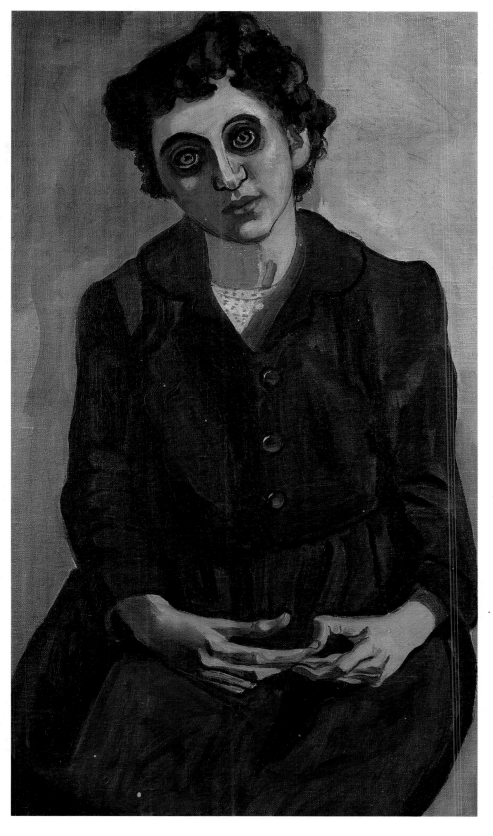

Plate 44
Mitzi Rosen
1952. Oil on canvas. 32 × 18 in. (81.3 × 45.7 cm.)

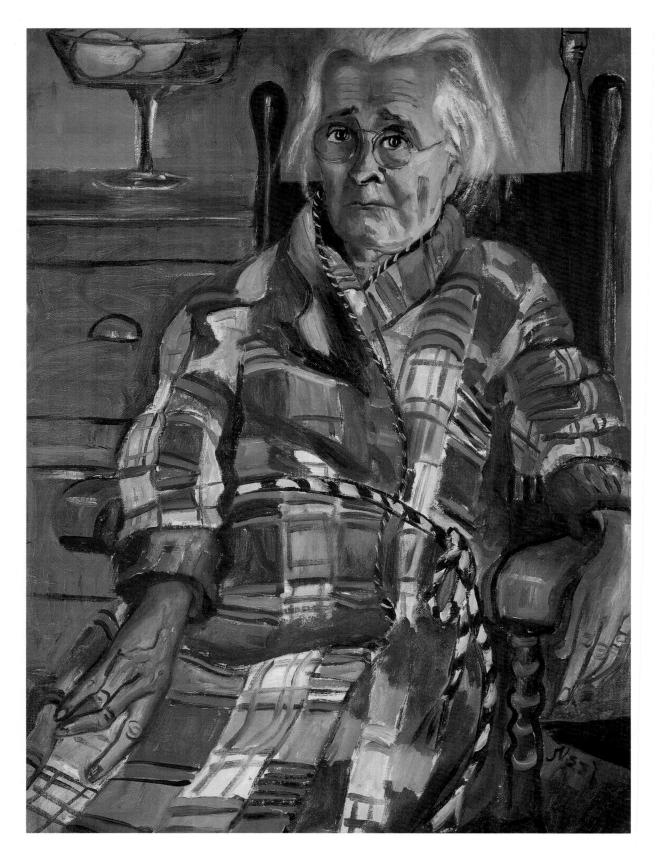

Plate 45
Last Sickness
1953. Oil on canvas. 30 × 22 in. (76.2 × 55.9 cm.)

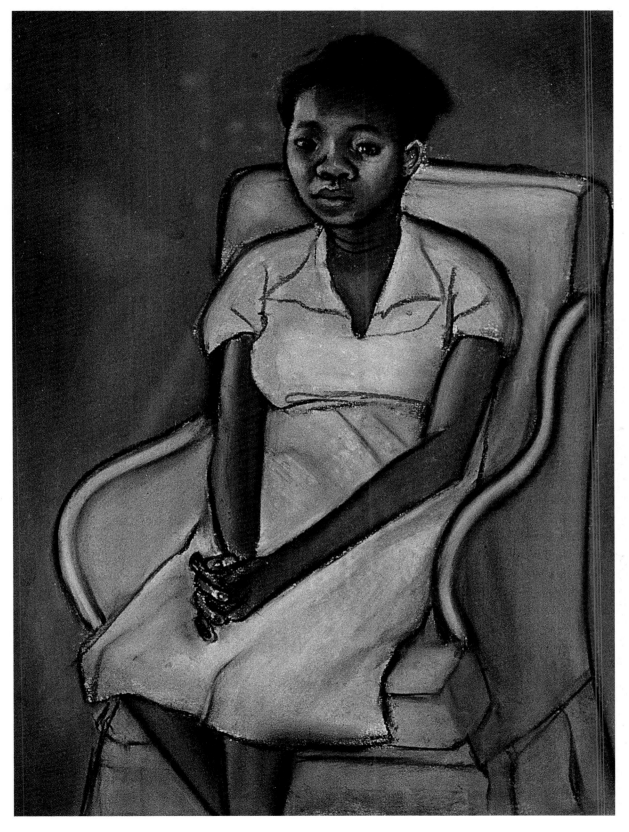

Plate 46
Nurse
1954. Pastel on paper. 29⁷/₈ × 22⁵/₈ in. (75.9 × 57.5 cm.)

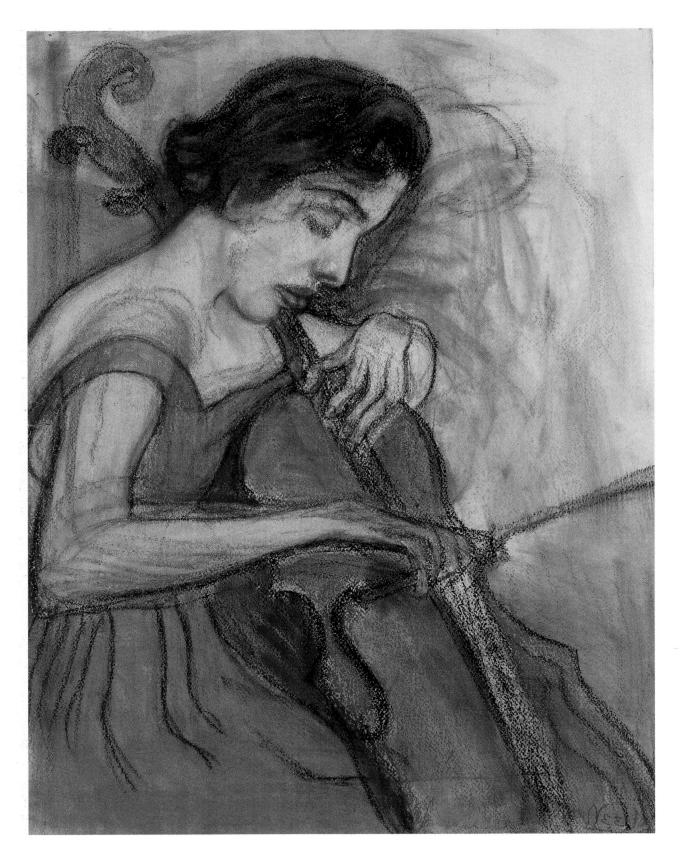

Plate 47
Woman Playing Cello
1955. Pastel on paper. 29 7/8 × 22 5/8 in. (75.9 × 57.5 cm.)

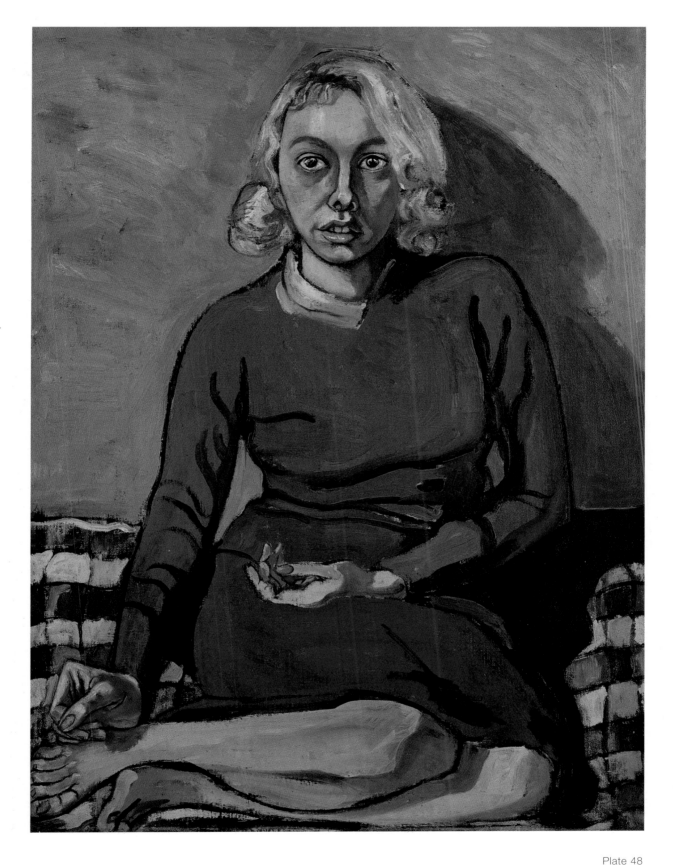

Plate 48
June
1955. Oil on canvas. 34 × 25 in. (86.4 × 63.5 cm.)

73

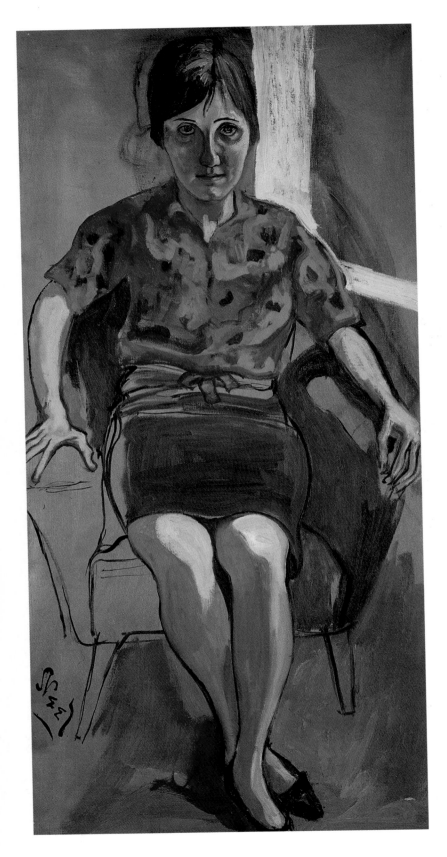

Plate 49
Christy White
1958. Oil on canvas. 50¼ × 24 in. (127.6 × 61 cm.)

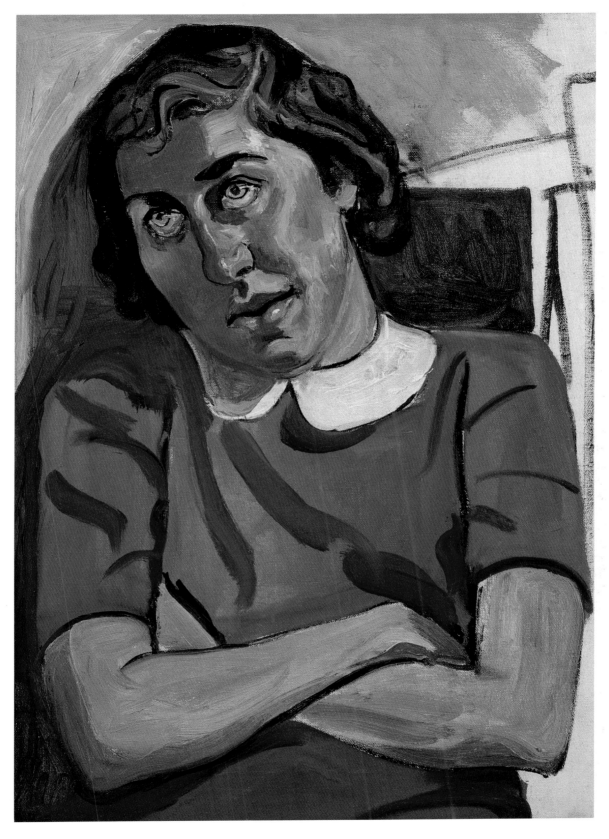

Plate 50
Religious Girl
1958. Oil on canvas. 24 × 17 in. (61 × 43.2 cm.)

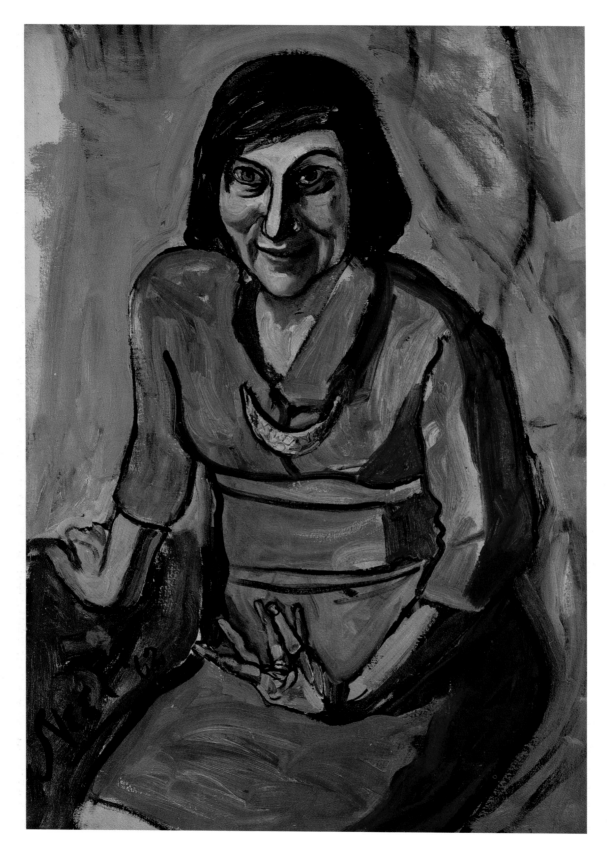

Plate 51
Lida
1962. Oil on canvas. 34 × 23 in. (86.4 × 58.4 cm.)

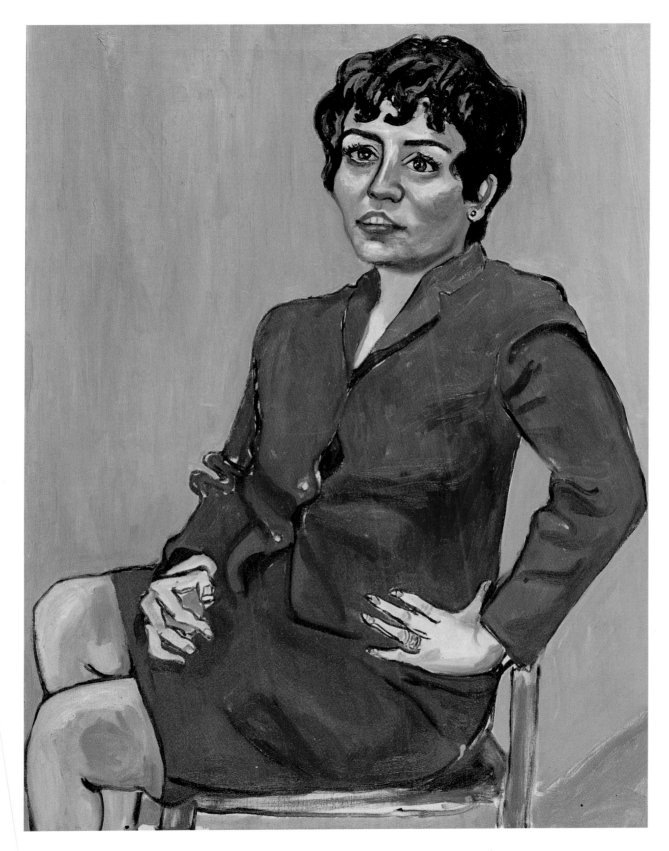

Plate 52
Geza's Wife
1964. Oil on canvas. 40 × 30 in. (101.6 × 76.2 cm.)

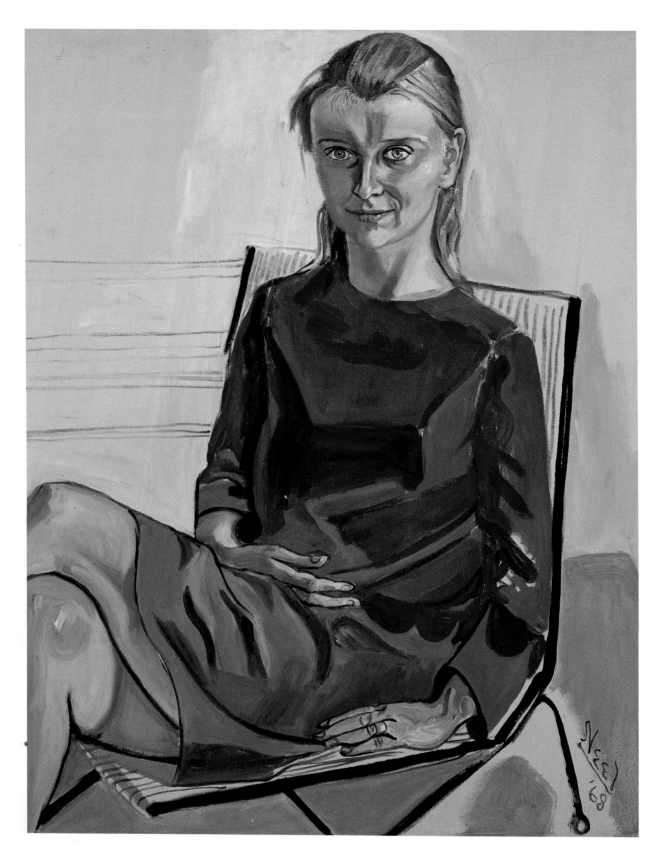

Plate 53
Monika
1968. Oil on canvas. 40 × 30 in. (101.6 × 76.2 cm.)

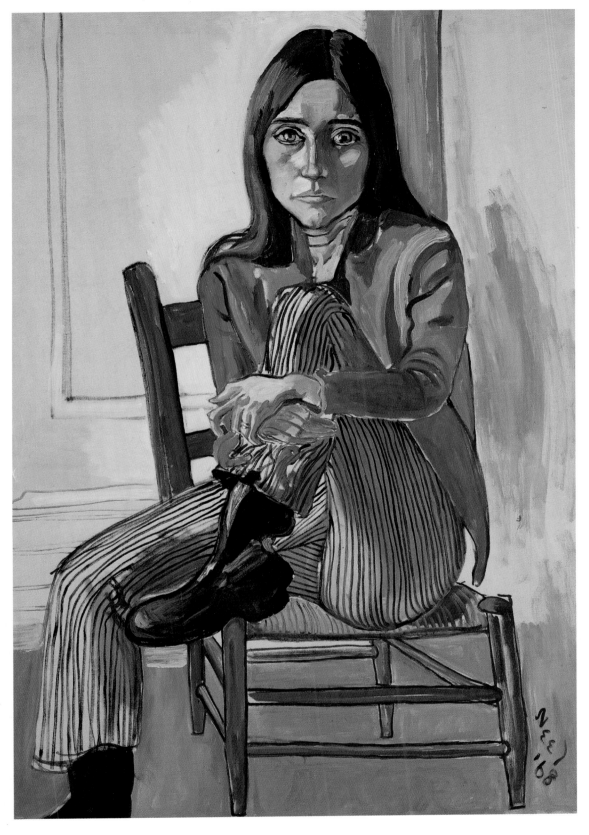

Plate 54
Nancy Selvage
1968. Oil on canvas. 48 × 33 in. (121.9 × 83.8 cm.)

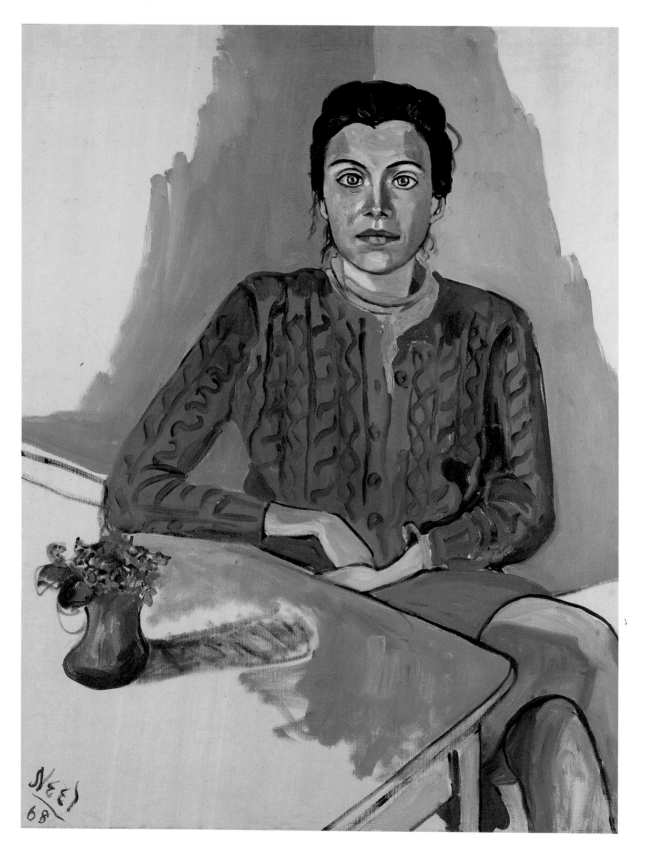

Plate 55
Nancy
1968. Oil on canvas. 47 × 34 in. (119.4 × 86.4 cm.)

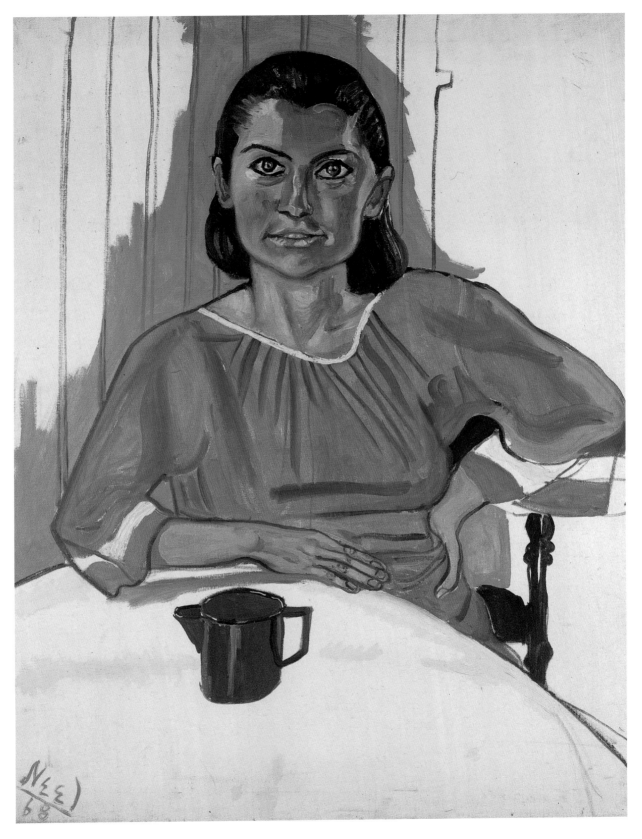

Plate 56
Leah
1968. Oil on canvas. 40 × 30 in. (101.6 × 76.2 cm.)

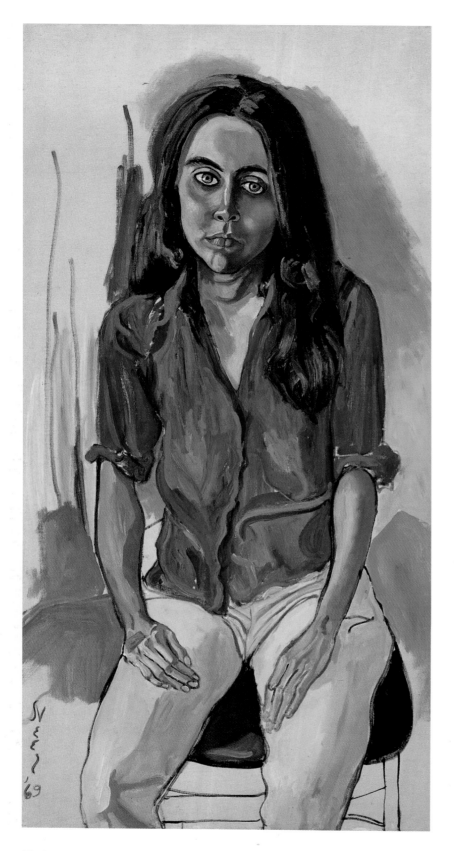

Plate 57
Ginny in Blue Shirt
1969. Oil on canvas. 48 × 24 in. (121.9 × 61 cm.)

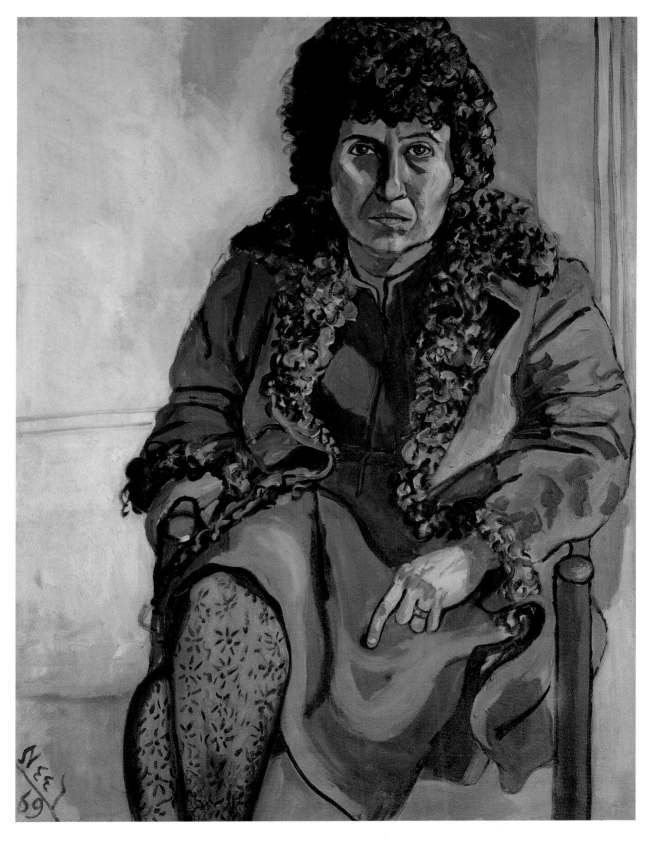

Plate 58
Dorothy Pearlstein
1969. Oil on canvas. 39¾ × 29¾ in. (101 × 75.6 cm.)

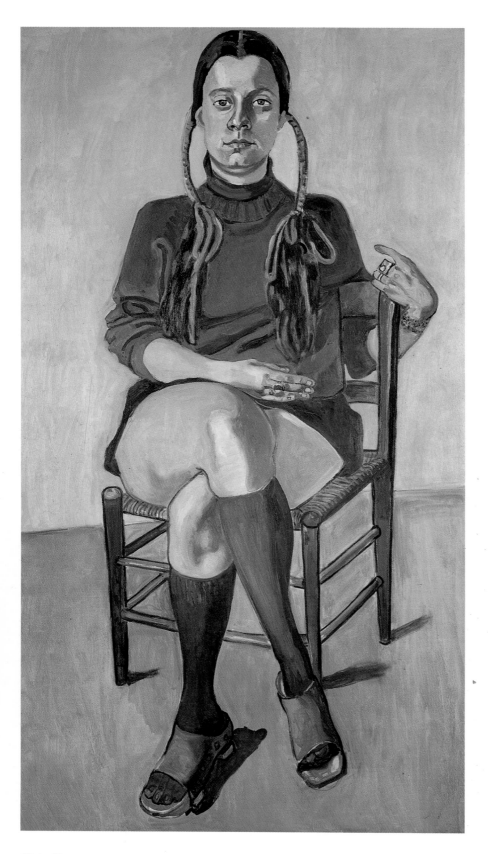

Plate 59
Vera Beckerhoff
1972. Oil on canvas. 60 × 32 in. (152.4 × 81.3 cm.)

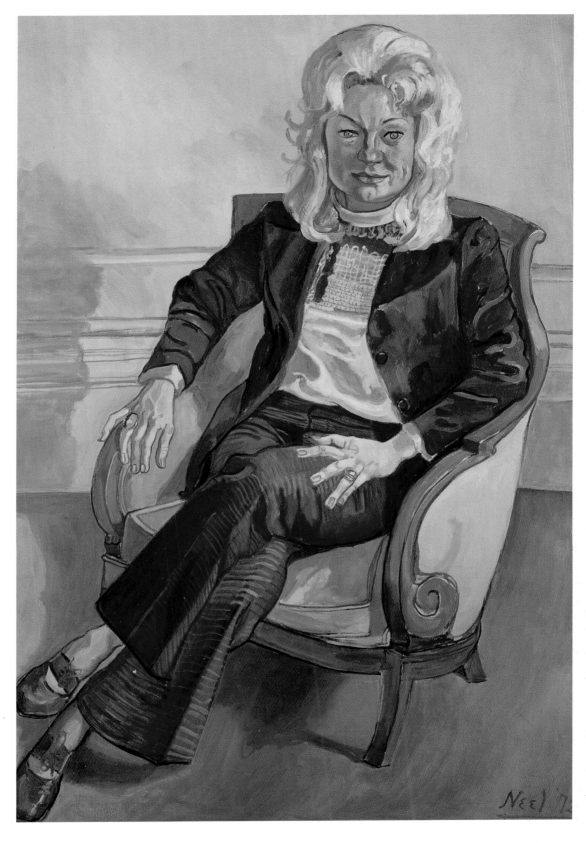

Plate 60
June Blum
1972. Oil on canvas. 60 × 40 in. (152.4 × 101.6 cm.)

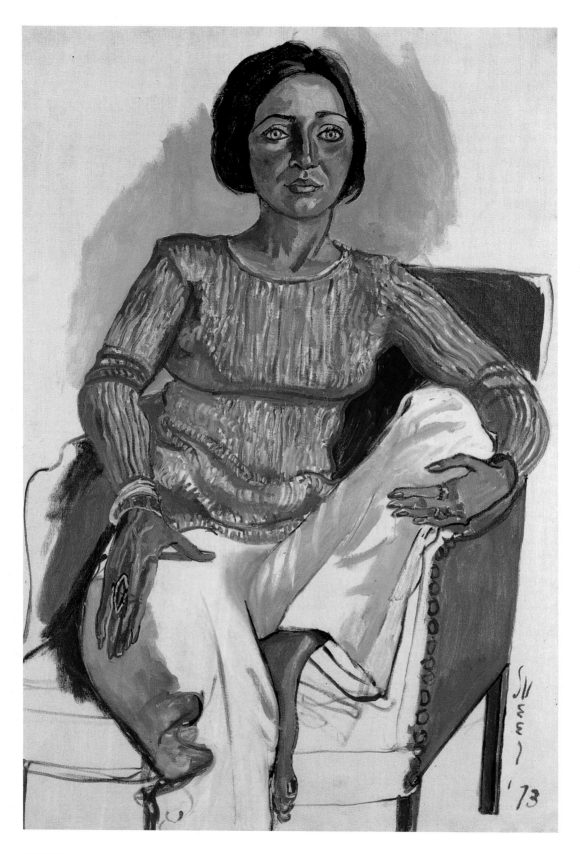

Plate 61
Dianne Vanderlip
1973. Oil on canvas. 45½ × 29½ in. (115.6 × 74.9 cm.)

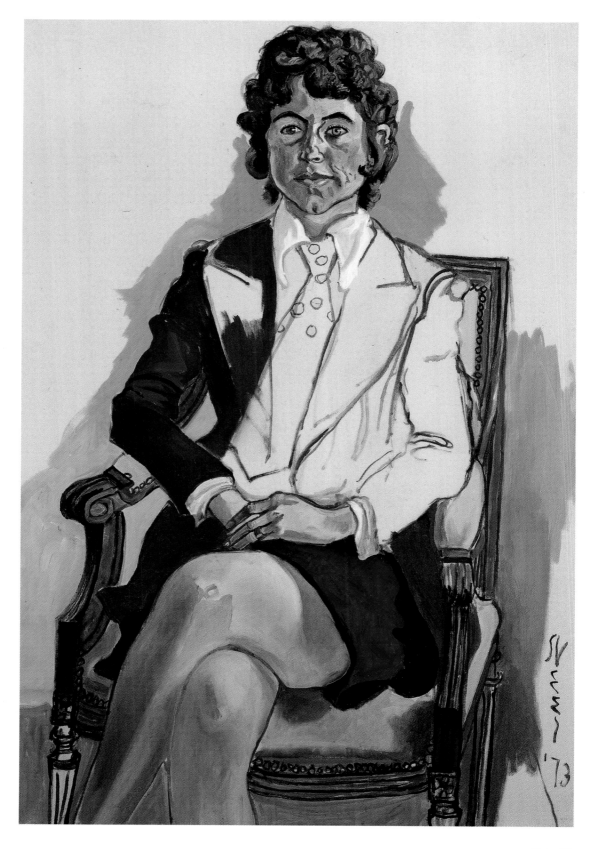

Plate 62
Diane Cochrane
1973. Oil on canvas. 43 × 30 in. (109.2 × 76.2 cm.)

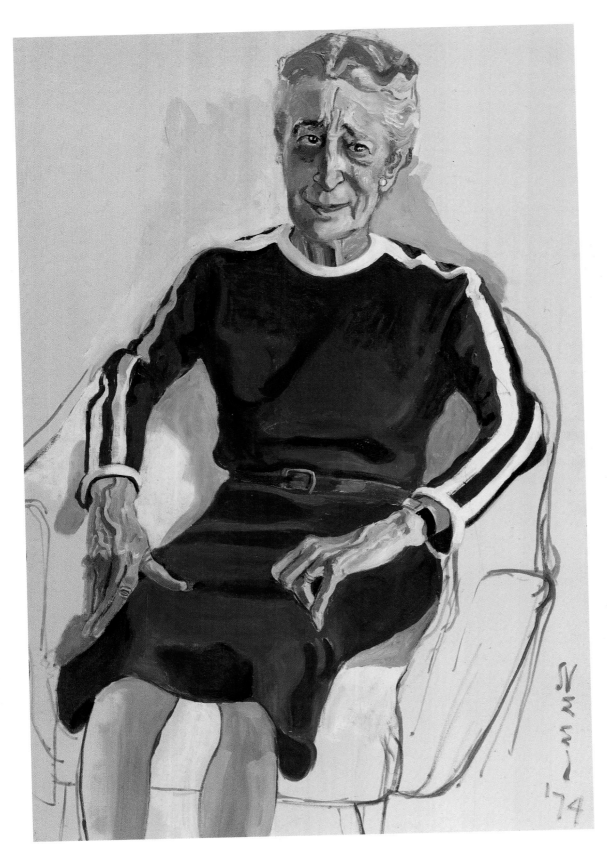

Plate 63
Isabel Bishop
1974. Oil on canvas. 44 × 30 in. (111.8 × 76.2 cm.)

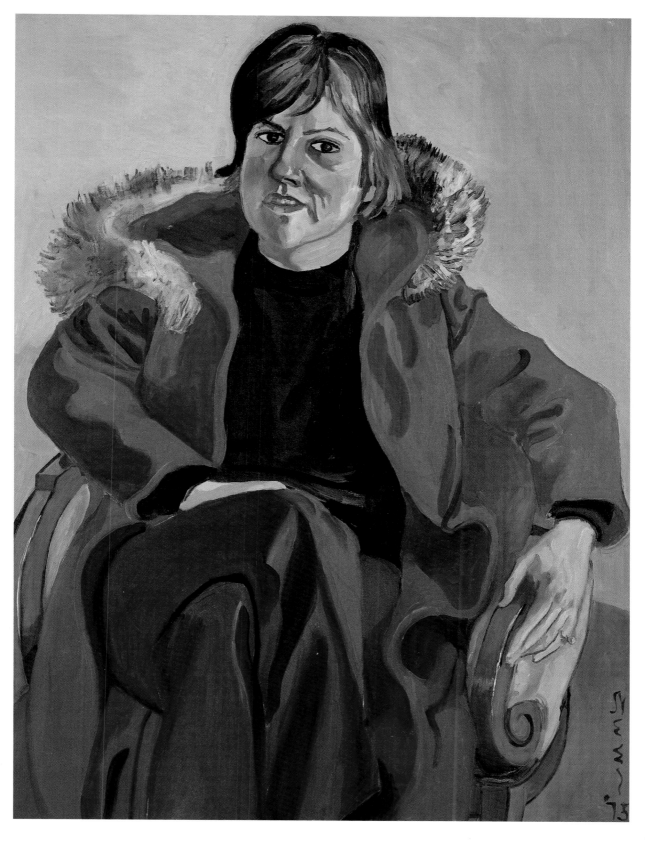

Plate 64
Mary Beebe
1975. Oil on canvas. 40 × 30 in. (101.6 × 76.2 cm.)

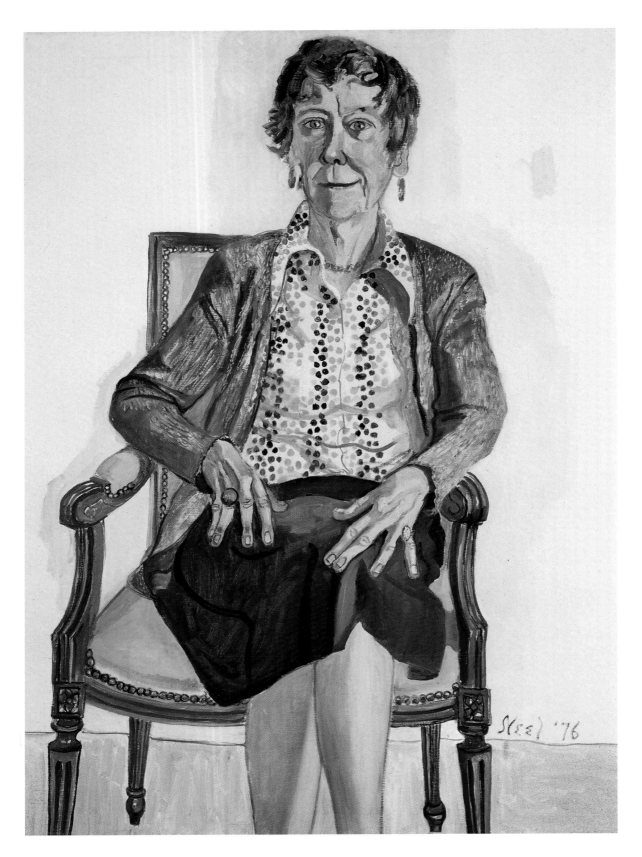

Plate 65
Ellen Johnson
1976. Oil on canvas. 44 × 38 in. (111.8 × 96.5 cm.)

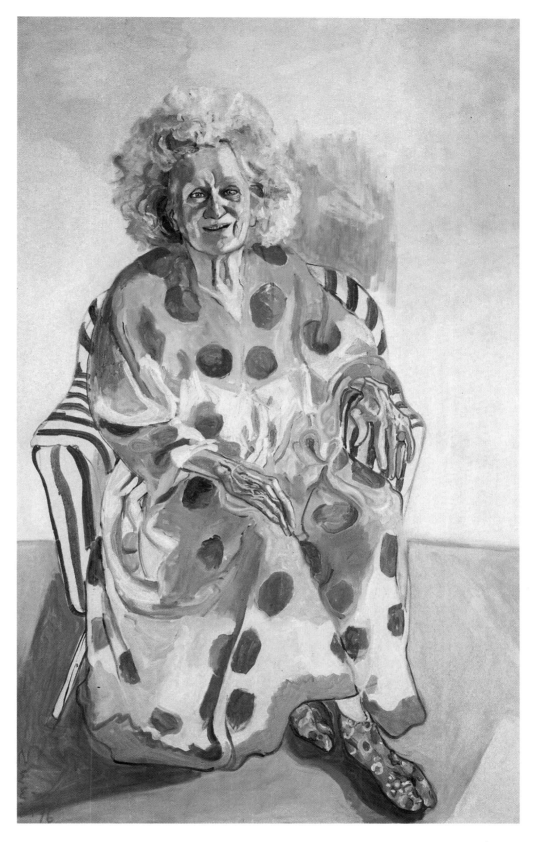

Plate 66
Sari Dienes
1976. Oil on canvas. 59¾ × 38 in. (151.8 × 96.5 cm.)

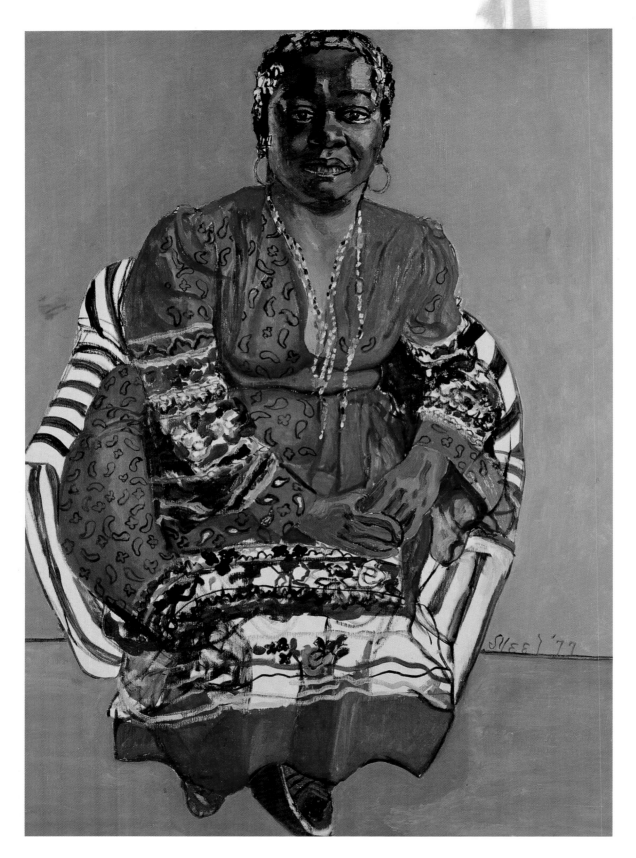

Plate 67
Faith Ringgold
1977. Oil on canvas. 48 × 36 in. (121.9 × 91.4 cm.)

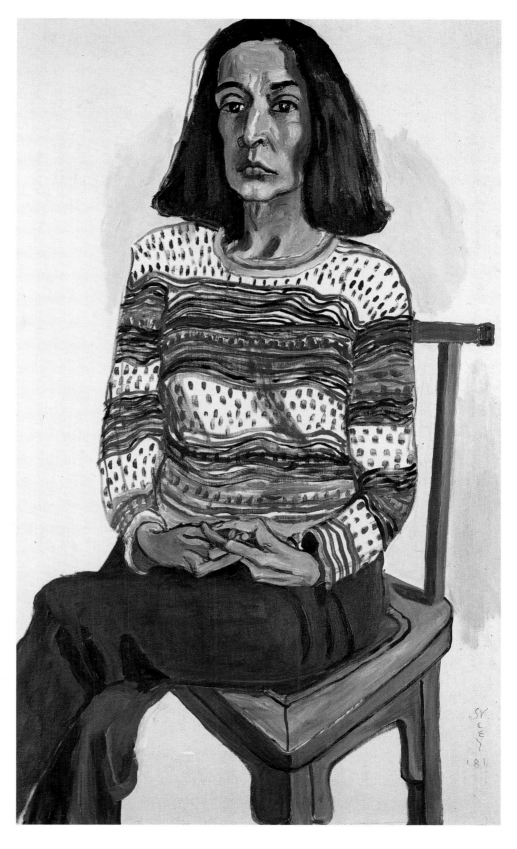

Plate 68
Marisol
1981. Oil on canvas. 42 × 25 in. (106.7 × 63.5 cm.)

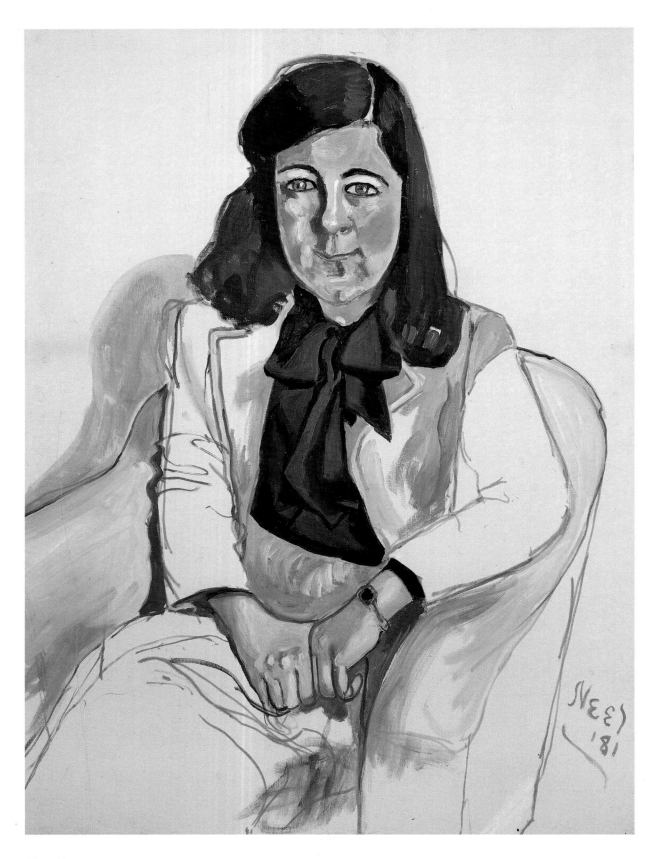

Plate 69
Marilyn Symmes
1981. Oil on canvas. 40 × 30 in. (101.6 × 76.2 cm.)

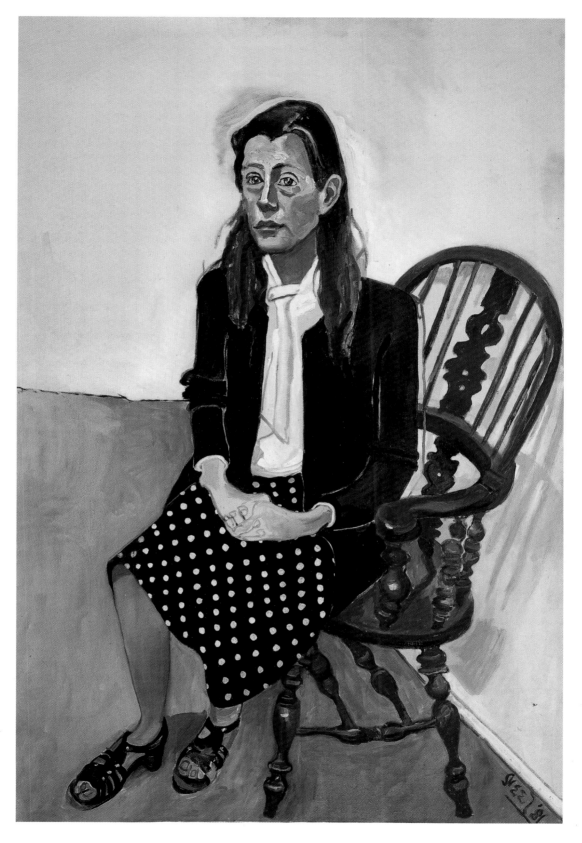

Plate 70
Nancy
1981. Oil on canvas. 60 × 40 in. (152.4 × 101.6 cm.)

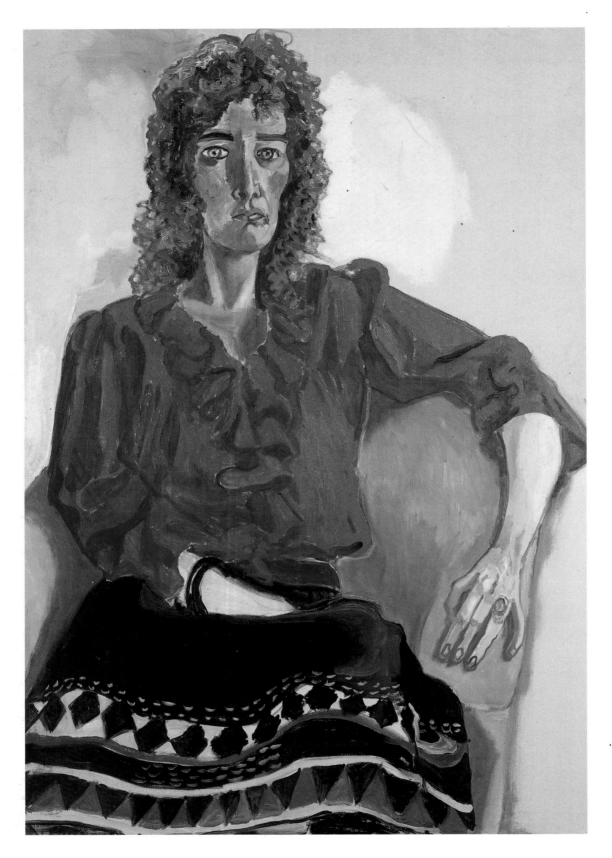

Plate 71
Catherine Jordan
1983. Oil on canvas. 44 × 30 in. (111.8 × 76.2 cm.)

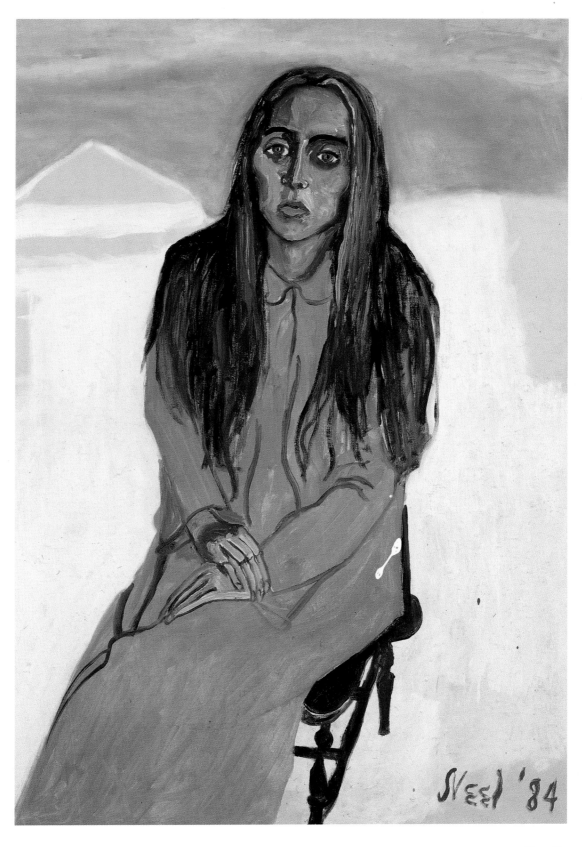

Plate 72
Ginny
1984. Oil on canvas. 44 × 30 in. (111.8 × 76.2 cm.)

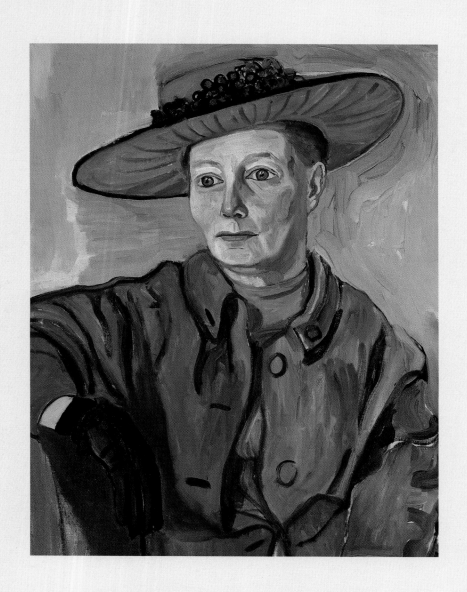

Dress

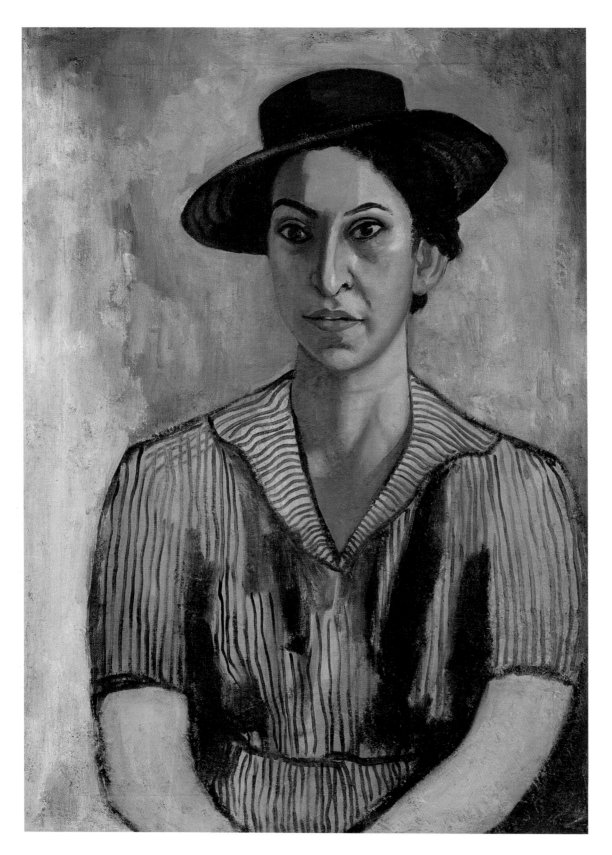

Plate 73
Woman with Blue Hat
1934. Oil on canvas. 32 × 22 in. (81.3 × 55.9 cm.)

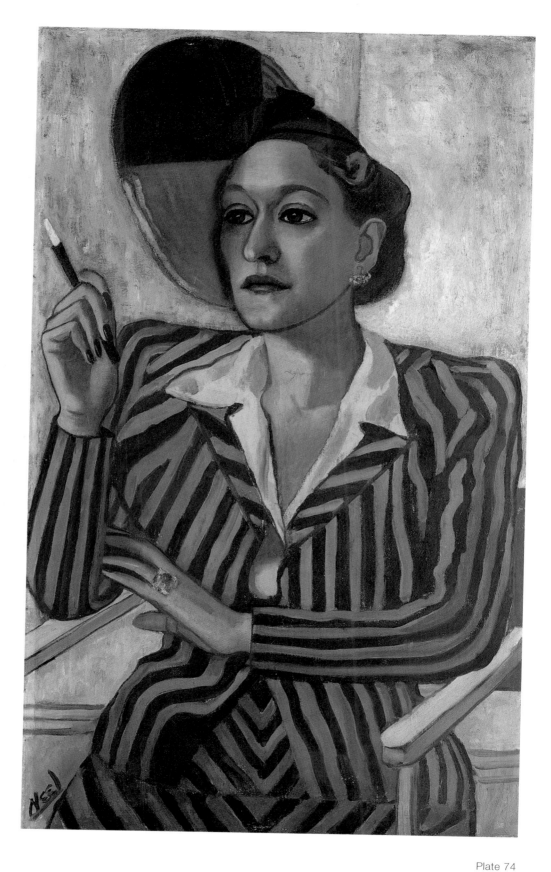

Plate 74
Mildred
c. 1937. Oil on canvas. 36¾ × 21¾ in. (93.3 × 55.2 cm.)

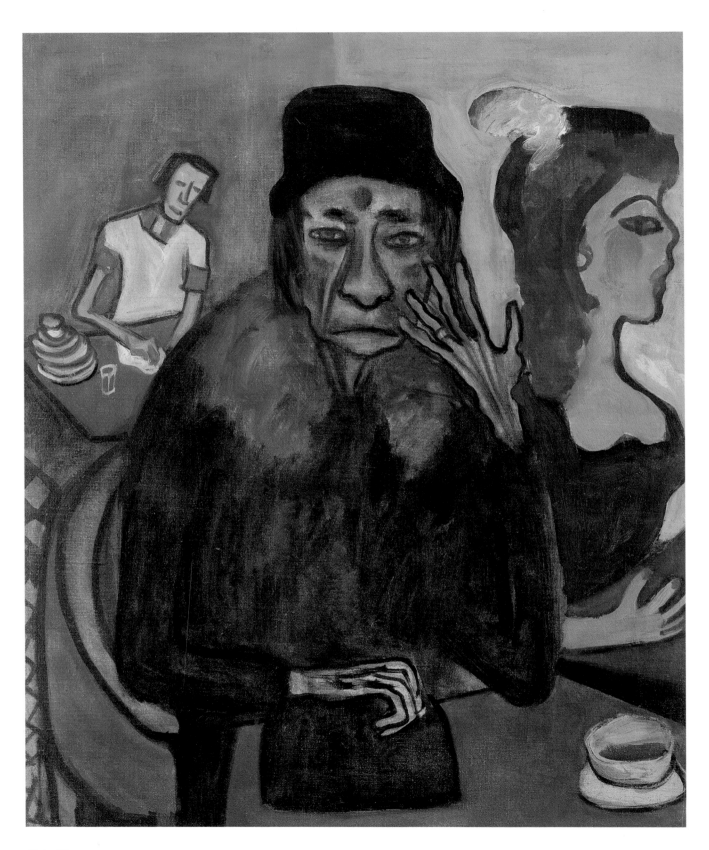

Plate 75
The Cafeteria
1938. Oil on canvas. 20 × 16 in. (50.8 × 40.6 cm.)

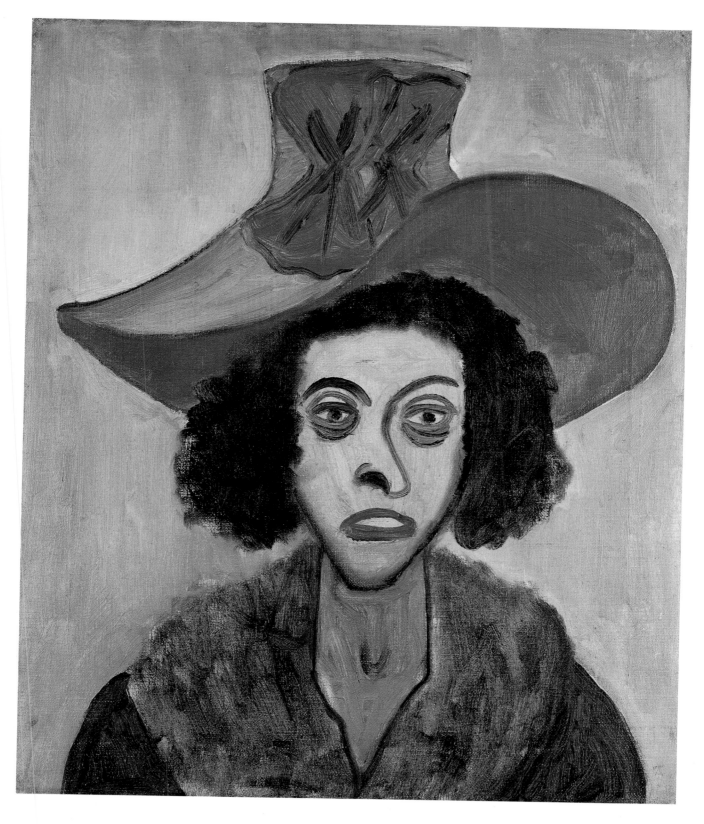

Plate 76
Woman in Pink Velvet Hat
1944. Oil on canvas. 18 × 14 in. (45.7 × 35.6 cm.)

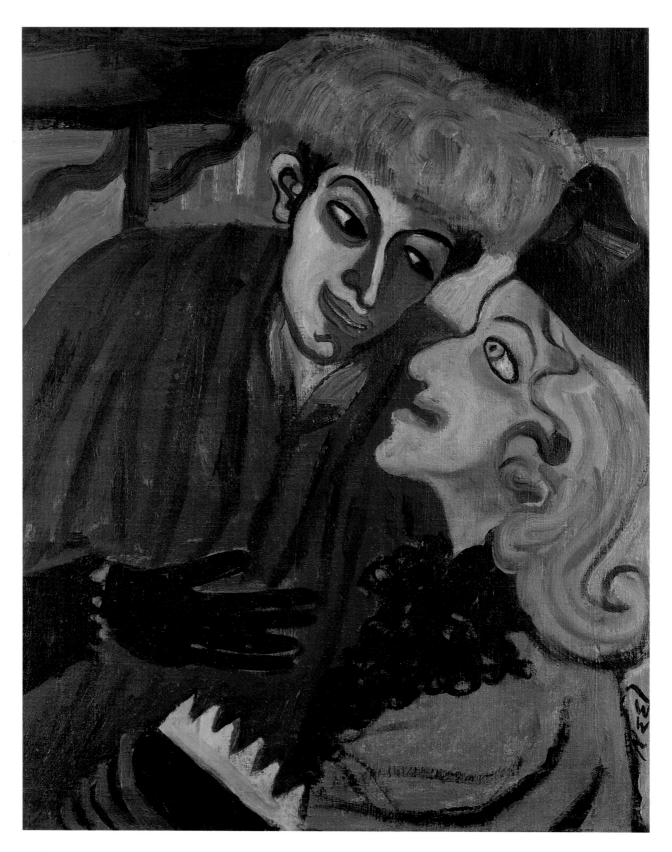

Plate 77
Conversation on a Bus
1944. Oil on canvas. 29 × 22 in. (73.7 × 55.9 cm.)

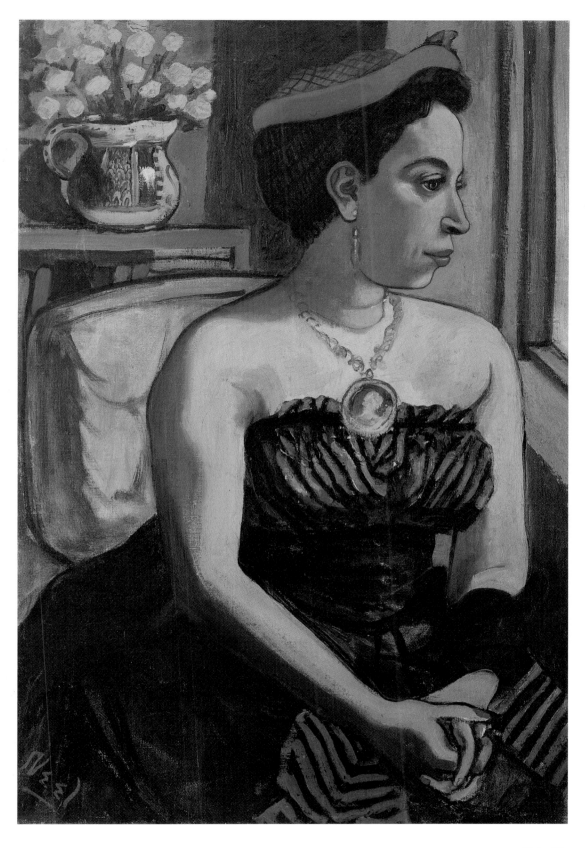

Plate 78
Alice Childress
1950. Oil on canvas. 29⅞ × 20 in. (75.9 × 50.8 cm.)

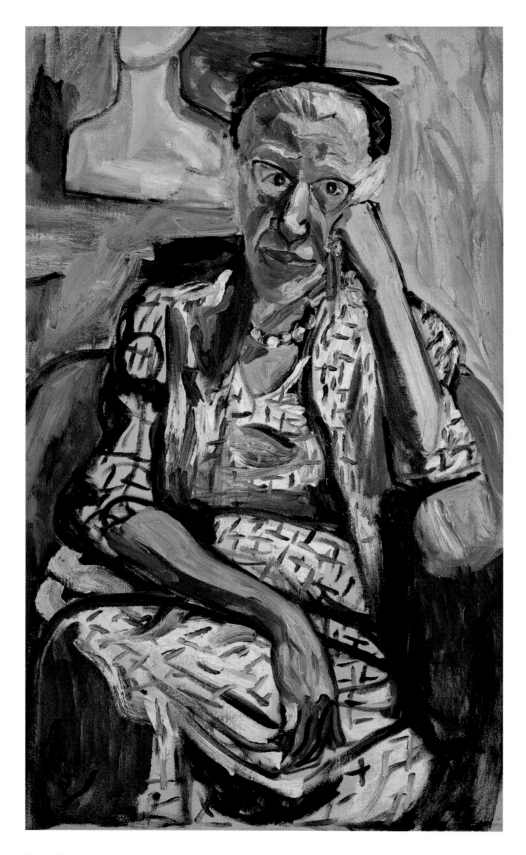

Plate 79
The Baron's Aunt
1959. Oil on canvas. 38 × 22 in. (96.5 × 55.9 cm.)

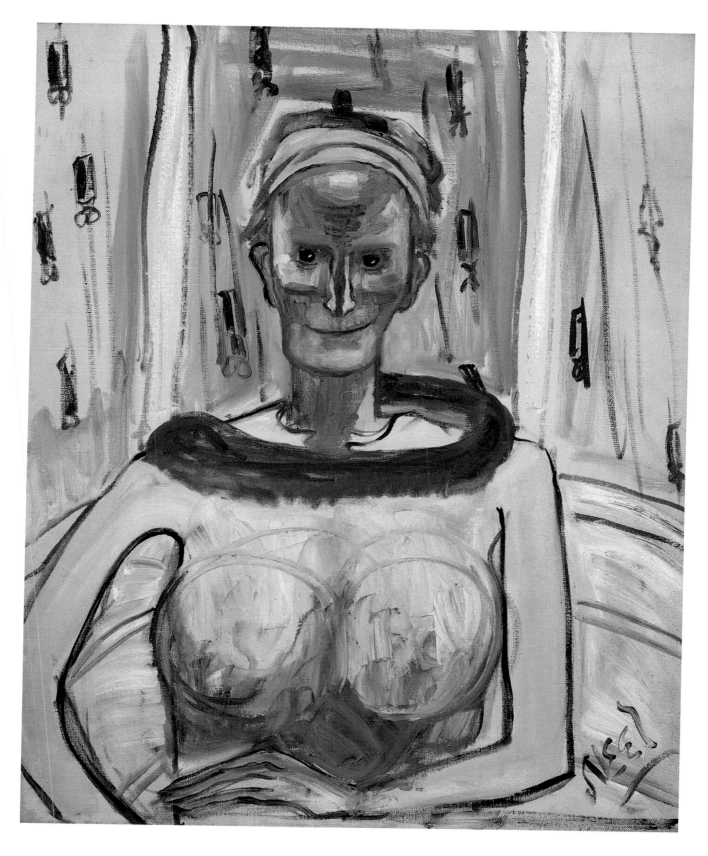

Plate 80
Ellie Poindexter
1962. Oil on canvas. 30 × 24 in. (76.2 × 61 cm.)

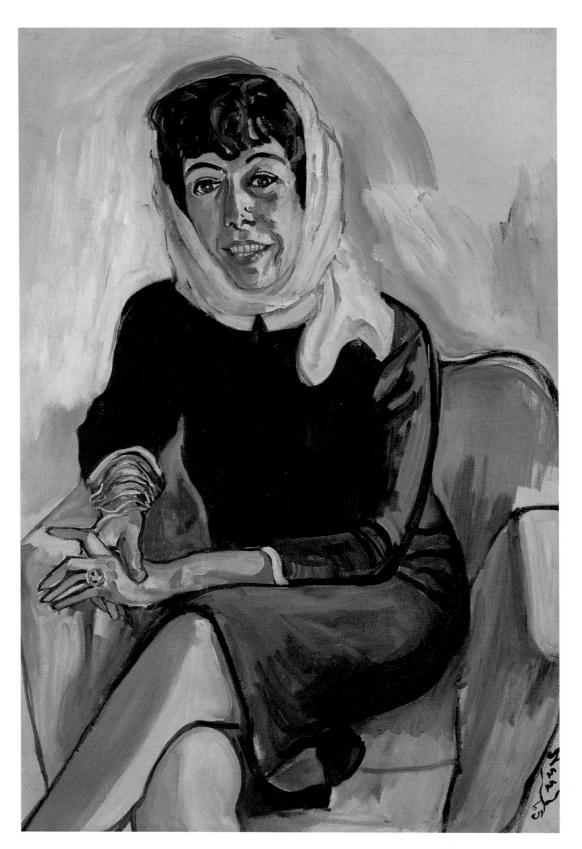

Plate 81
Vivienne Wechter
1965. Oil on canvas. 39 × 25¼ in. (99.1 × 64.1 cm.)

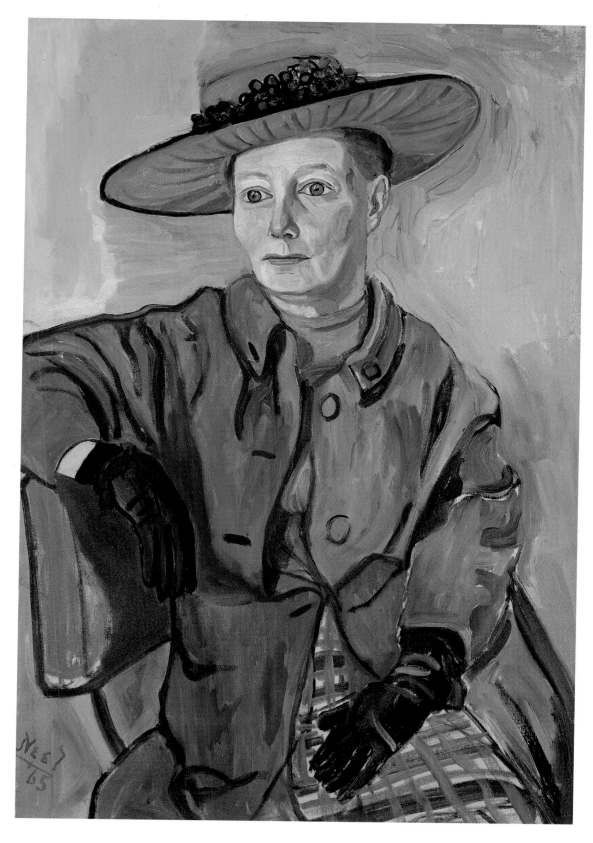

Plate 82
Mary Shoemaker
1965. Oil on canvas. 38$\frac{7}{8}$ × 26 in. (98.7 × 66 cm.)

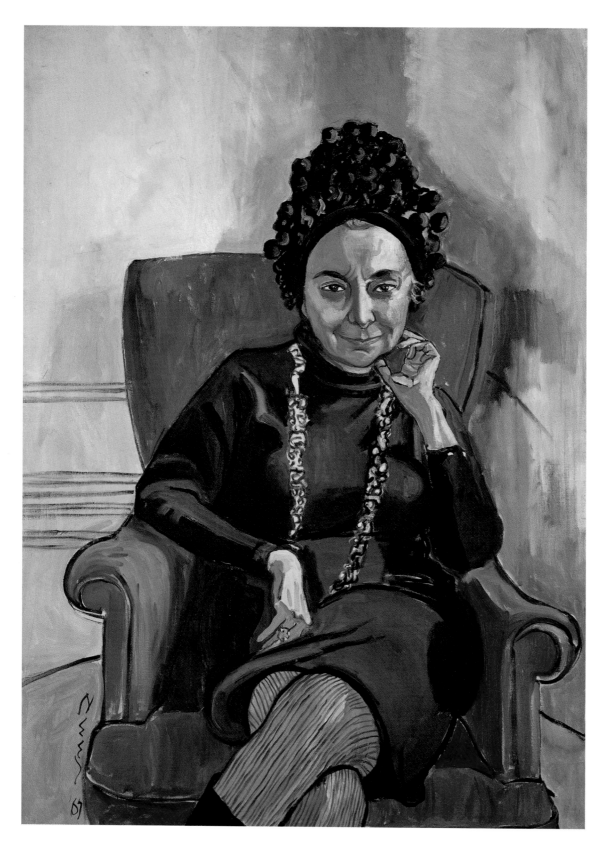

Plate 83

Charlotte Willard

1967. Oil on canvas. 45$\frac{7}{8}$ × 30$\frac{7}{8}$ in. (116.5 × 78.4 cm.)

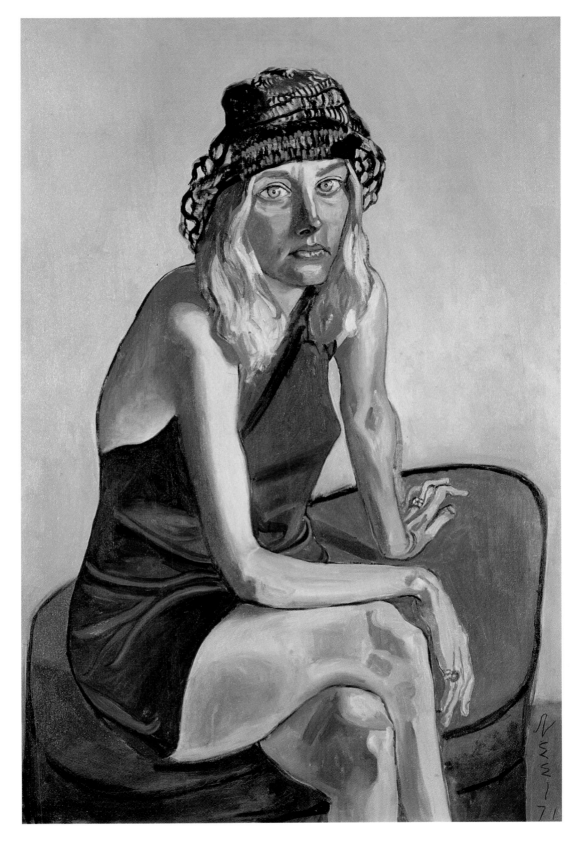

Plate 84
Louise Lieber
1971. Oil on canvas. 46 × 30 in. (116.8 × 76.2 cm.)

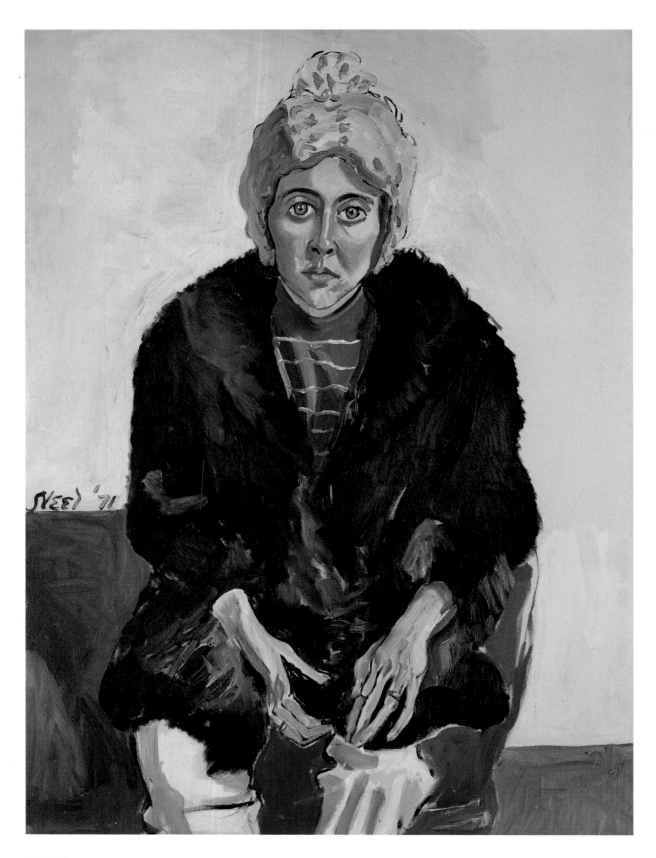

Plate 85
Ginny with Yellow Hat
1971. Oil on canvas. 40 × 29 in. (101.6 × 73.7 cm.)

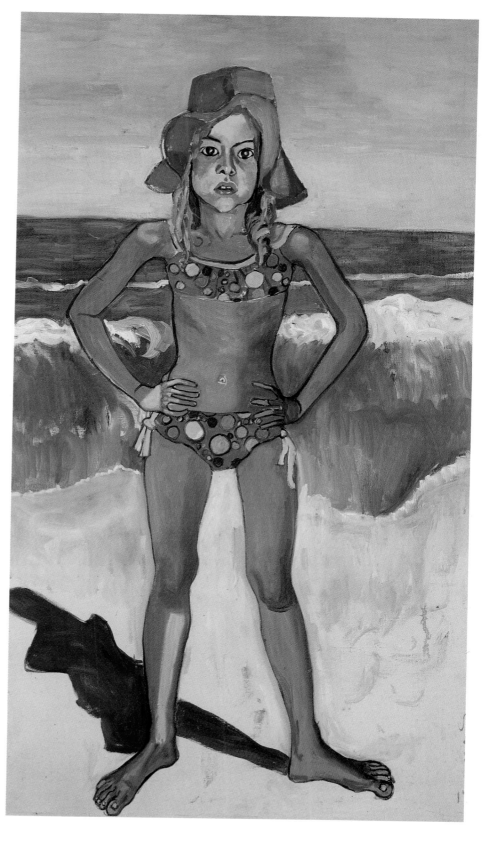

Plate 86
Olivia in Red Hat
1974. Oil on canvas. 54 × 32 in. (137.2 × 81.3 cm.)

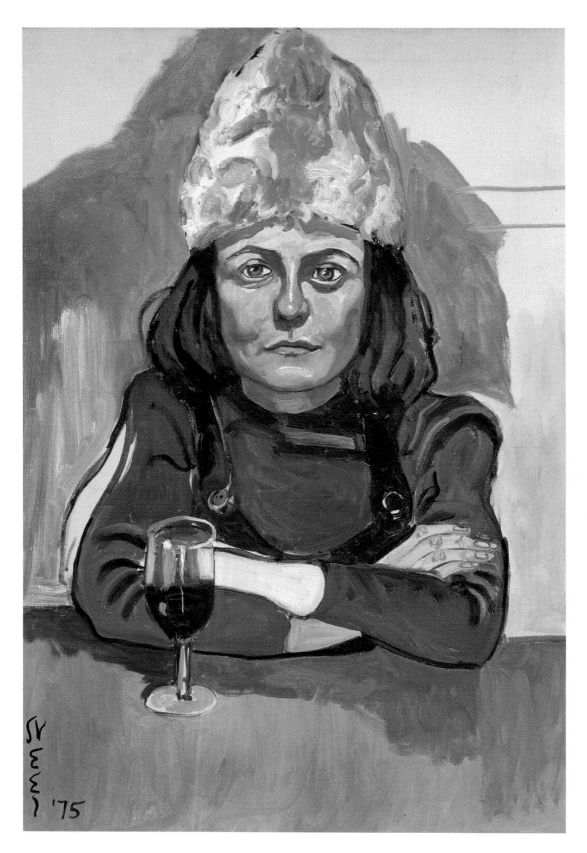

Plate 87
Woman in Cafe
1975. Oil on canvas. 36 × 24 in. (91.4 × 61 cm.)

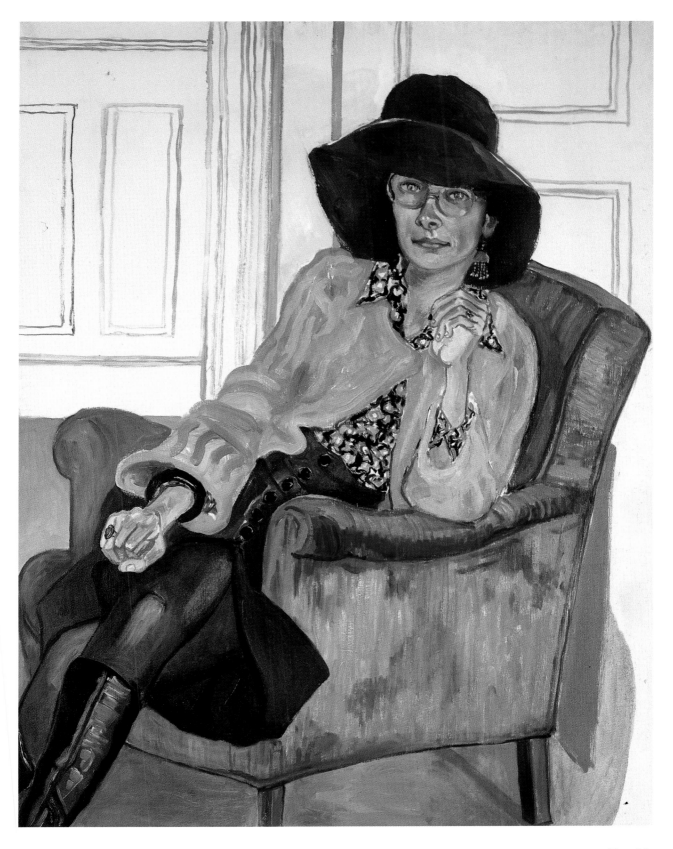

Plate 88
Susan Rossen
1976. Oil on canvas. 43¾ × 34 in. (111.1 × 86.4 cm.)

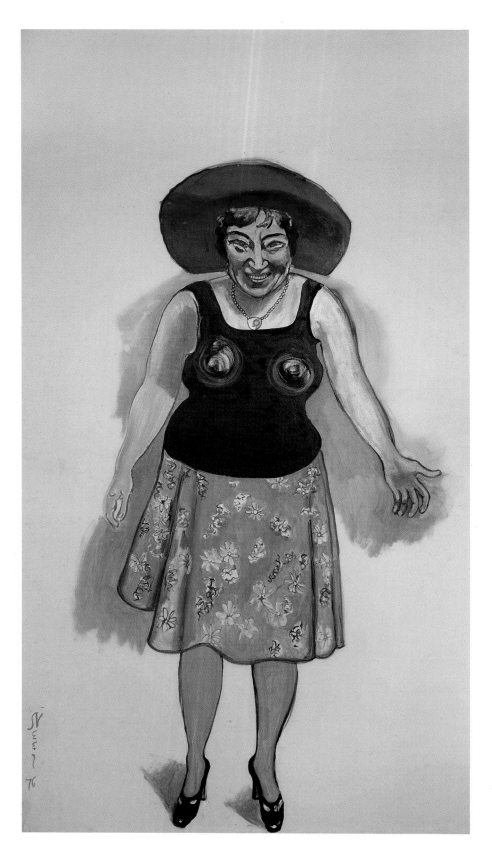

Plate 89
Bella Abzug
1976. Oil on canvas. 108 × 60 in. (274.3 × 152.4 cm.)

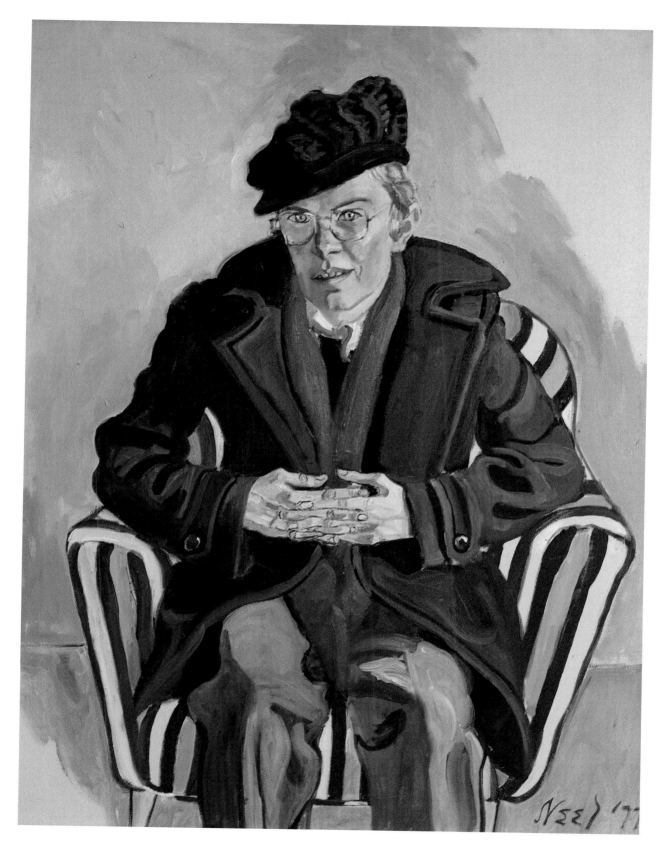

Plate 90
Mary D. Garrard
1977. Oil on canvas. 33¼ × 29¼ in. (84.5 × 74.3 cm.)

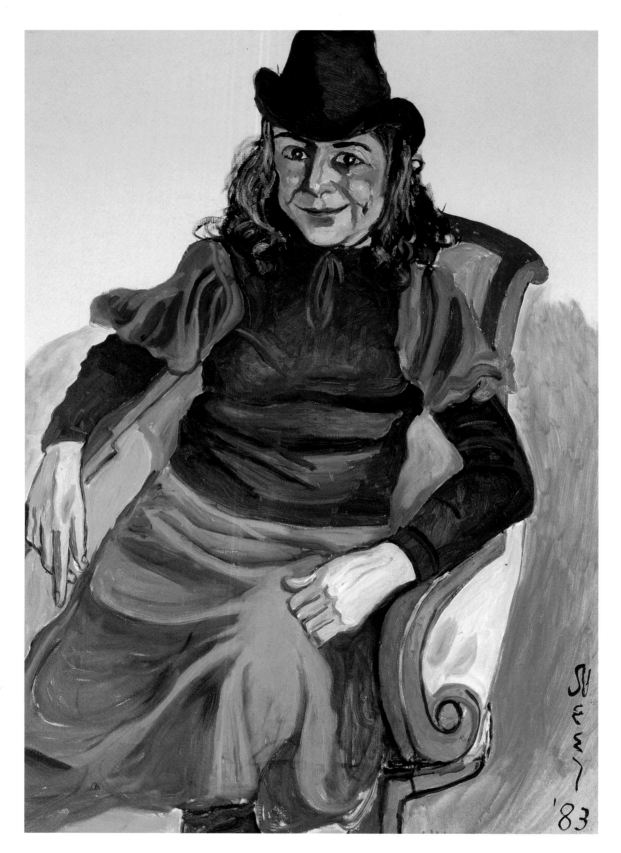

Plate 91
Vivien Leone
1983. Oil on canvas. 40 × 30 in. (101.6 × 76.2 cm.)

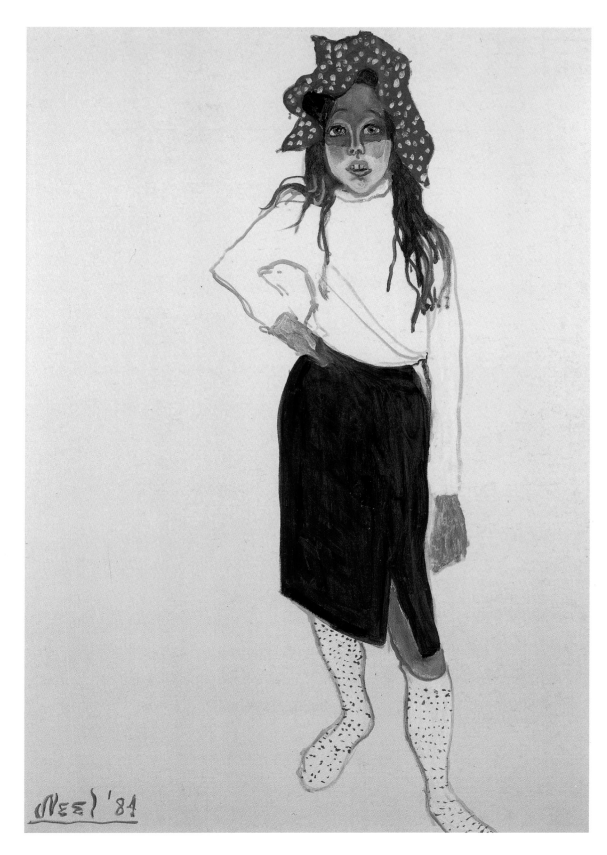

Plate 92
Elizabeth in Red Hat
1984. Oil on canvas. 46 × 32 in. (116.8 × 81.3 cm.)

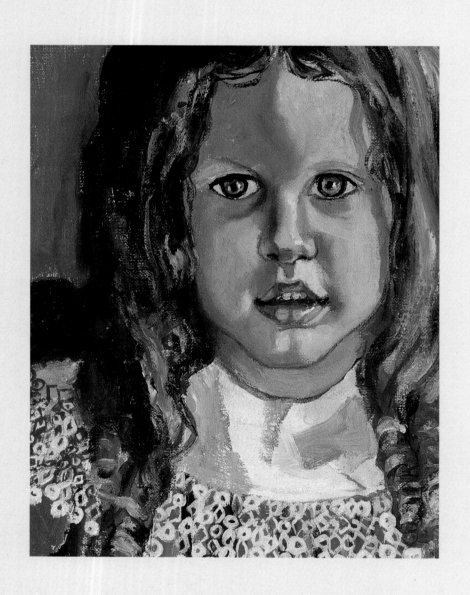

Children

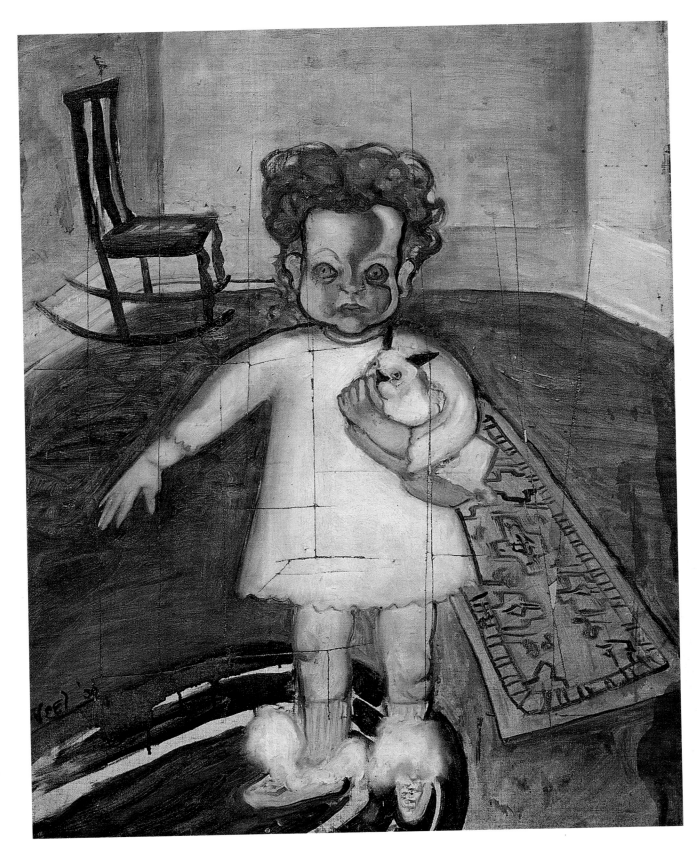

Plate 93
Isabetta
1930. Oil on canvas. 31 × 24 in. (78.7 × 61 cm.)

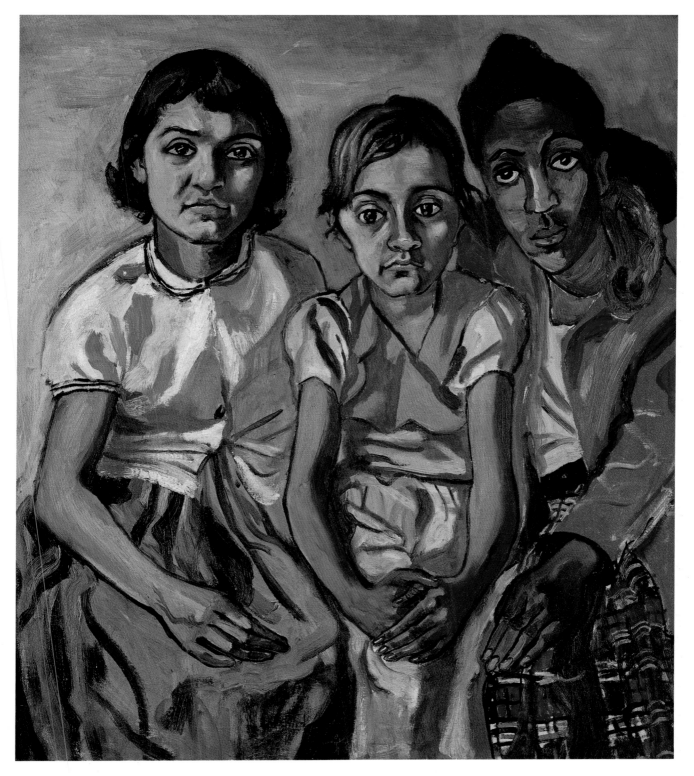

Plate 94
Three Puerto Rican Girls
1955. Oil on canvas. 32 × 28 in. (81.3 × 71.1 cm.)

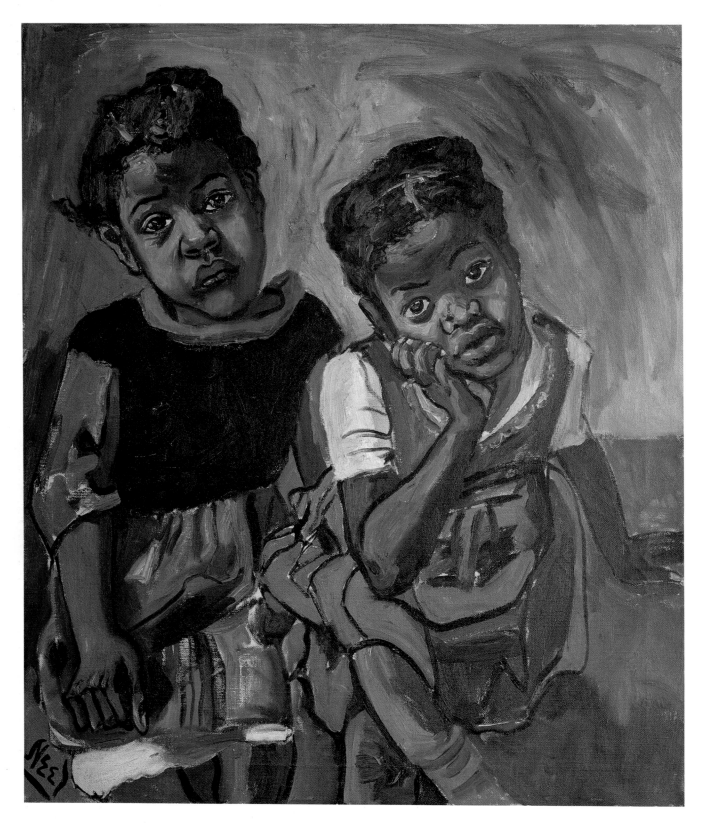

Plate 95
Two Girls, Spanish Harlem
1959. Oil on canvas. 30 × 25 in. (76.2 × 63.5 cm.)

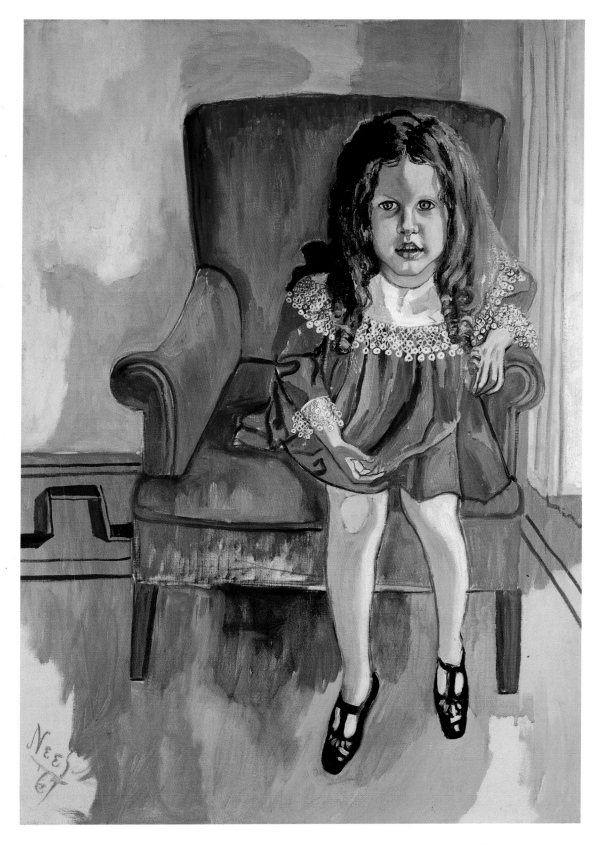

Plate 96
Clement Greenberg's Daughter
1967. Oil on canvas. 46 × 32 in. (116.8 × 81.3 cm.)

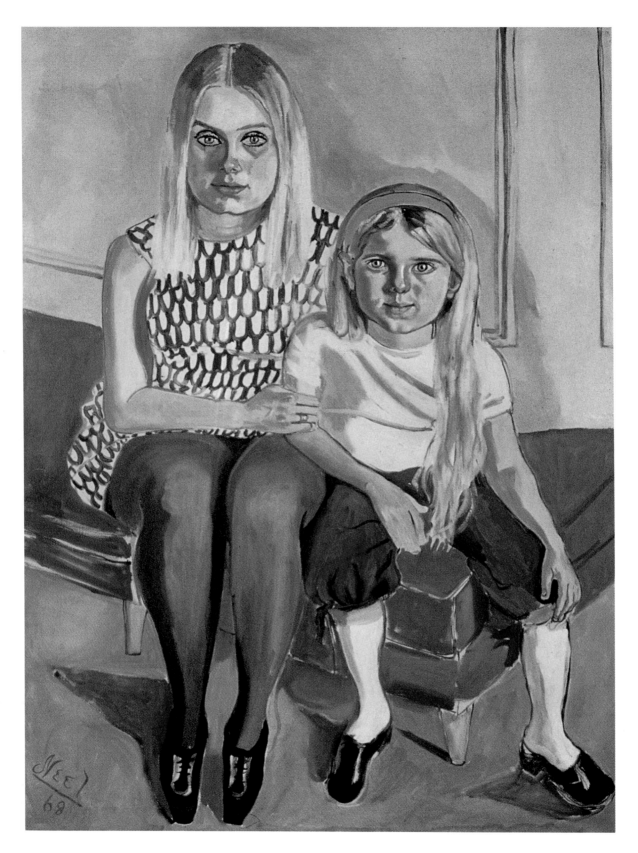

Plate 97
Swedish Girls
1968. Oil on canvas. 50 × 36 in. (127 × 91.4 cm.)

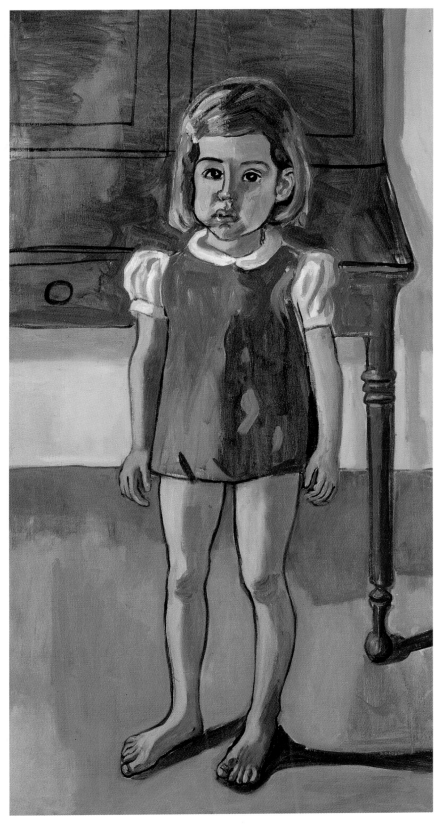

Plate 98
Olivia
1970. Oil on canvas. 47 × 24 in. (119.4 × 61 cm.)

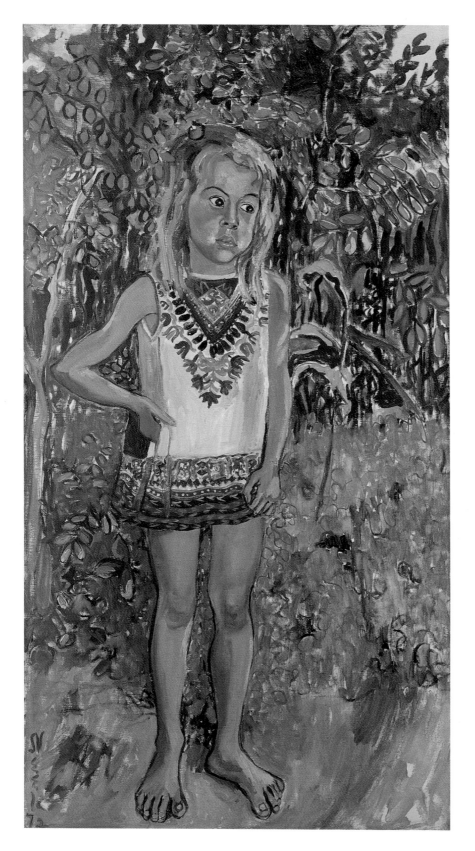

Plate 99
Olivia in an African Dress
1972. Oil on canvas. 54 × 28 in. (137.2 × 71.1 cm.)

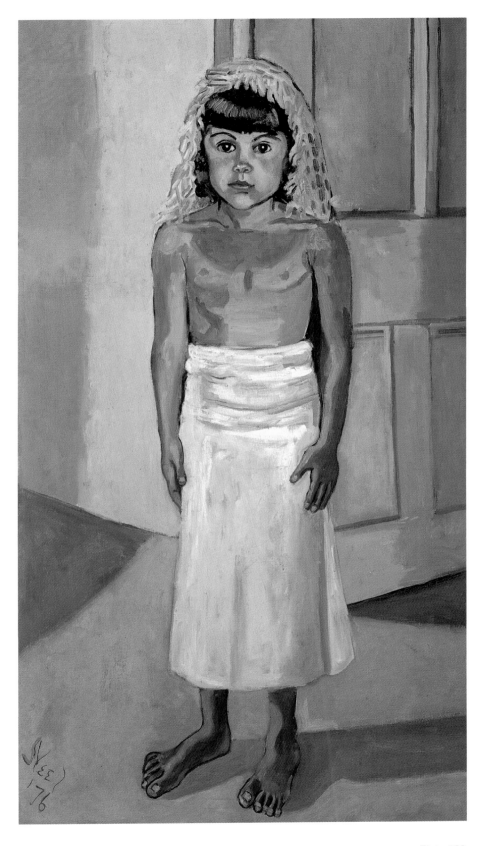

Plate 100
Alexandra
1976. Oil on canvas. 46 × 25 in. (116.8 × 63.5 cm.)

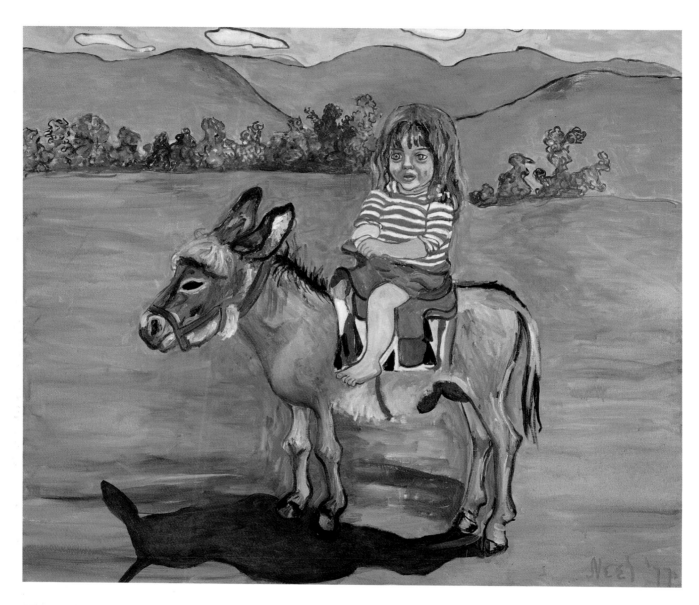

Plate 101

Elizabeth on the Donkey

1977. Oil on canvas. 44 × 50 in. (111.8 × 127 cm.)

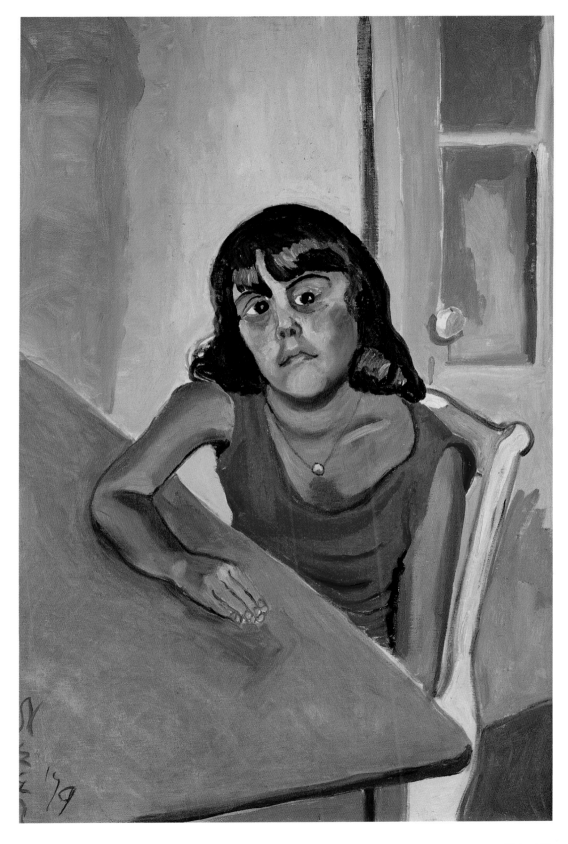

Plate 102
Antonia
1979. Oil on canvas. 36 × 23⅞ in. (91.4 × 60.6 cm.)

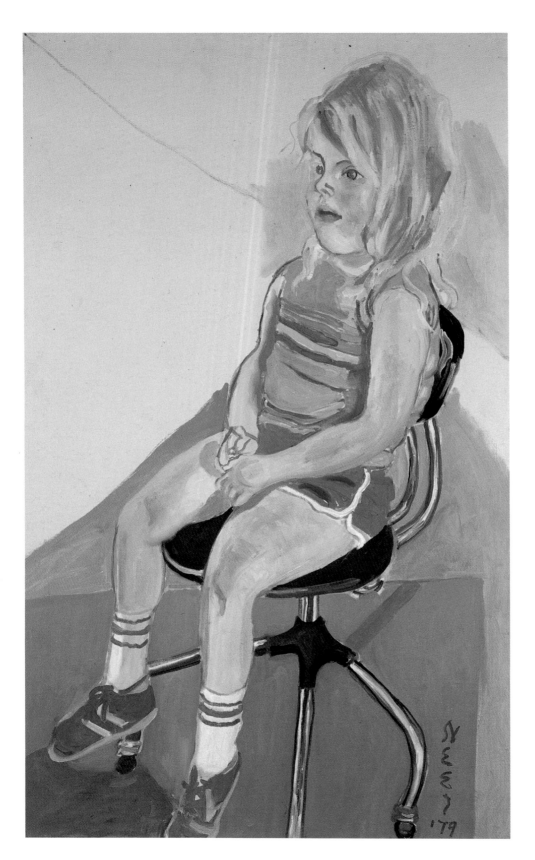

Plate 103
Victoria
1979. Oil on canvas. 42 × 25 in. (106.7 × 63.5 cm.)

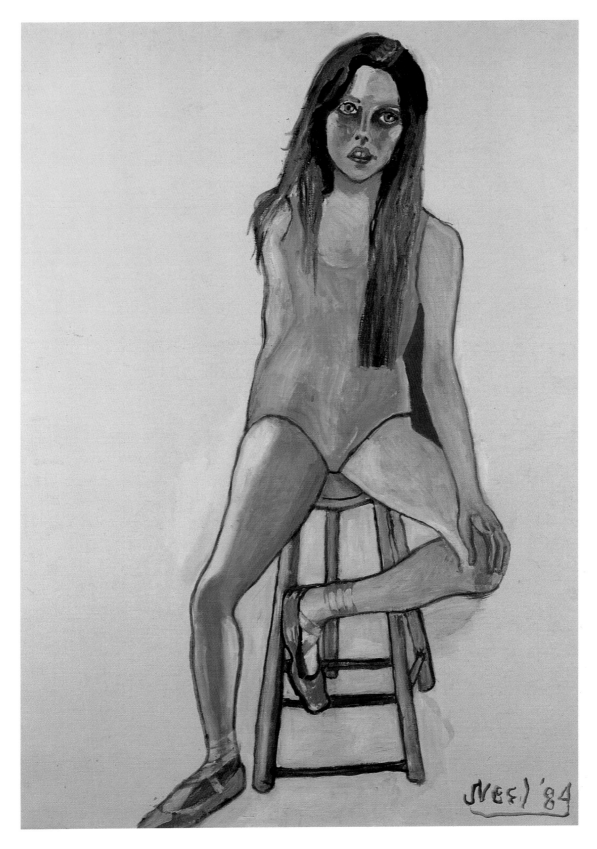

Plate 104
Elizabeth
1984. Oil on canvas. 46 × 32 in. (116.8 × 81.3 cm.)

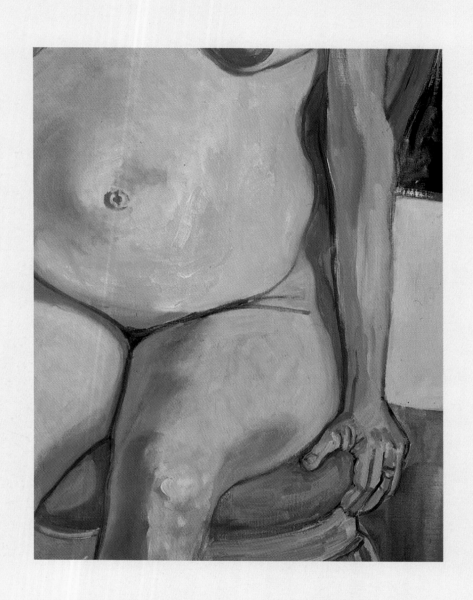

Nudes

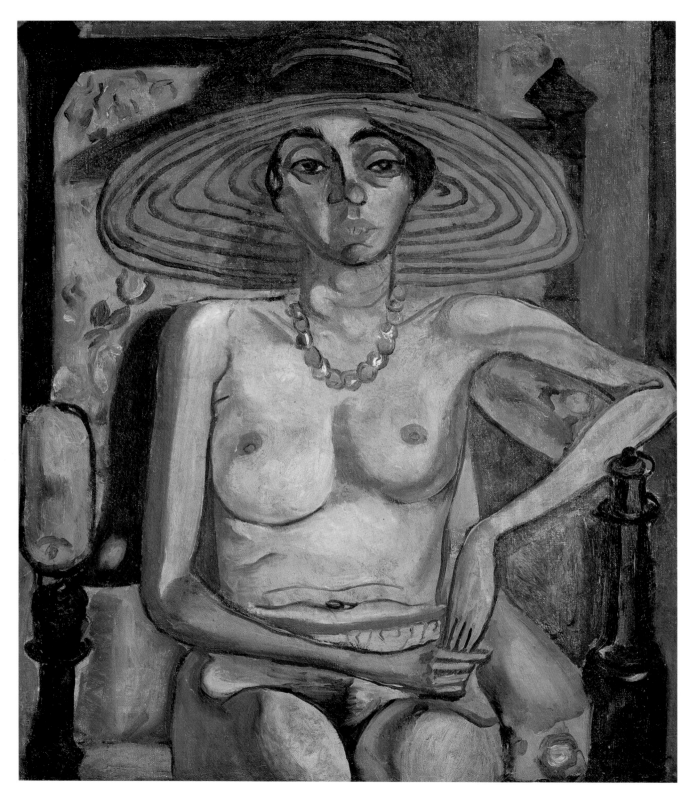

Plate 105
Rhoda Myers with Blue Hat
1930. Oil on canvas. 27$\frac{1}{2}$ × 23$\frac{1}{4}$ in. (69.9 × 59.1 cm.)

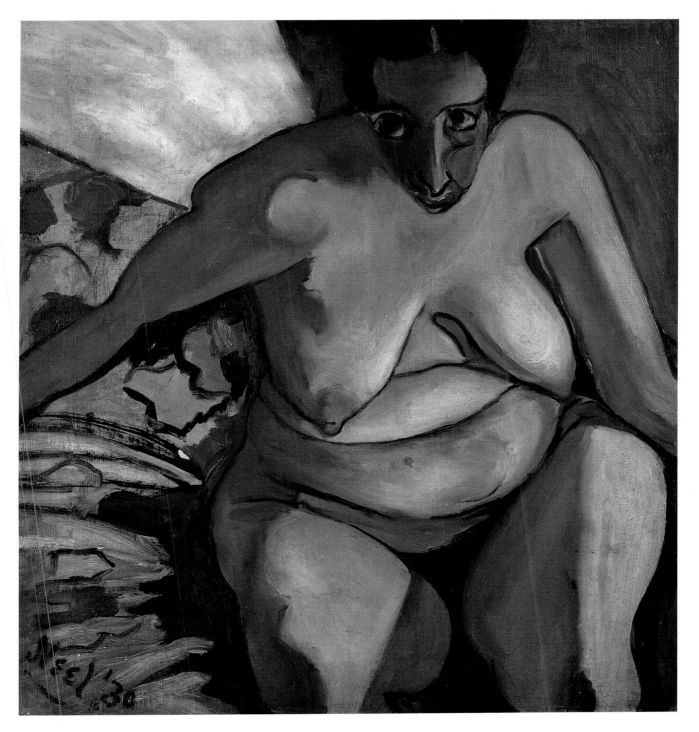

Plate 106
Ethel Ashton
1930. Oil on canvas. 24 × 22 in. (61 × 55.9 cm.)

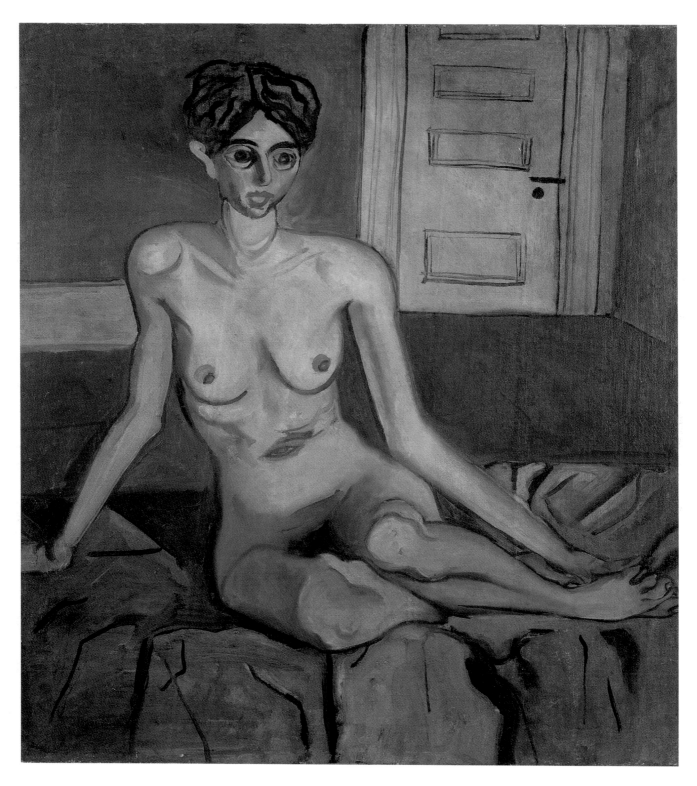

Plate 107
Rhoda Myers, Nude
1930. Oil on canvas. 29¾ × 26 in. (75.6 × 66 cm.)

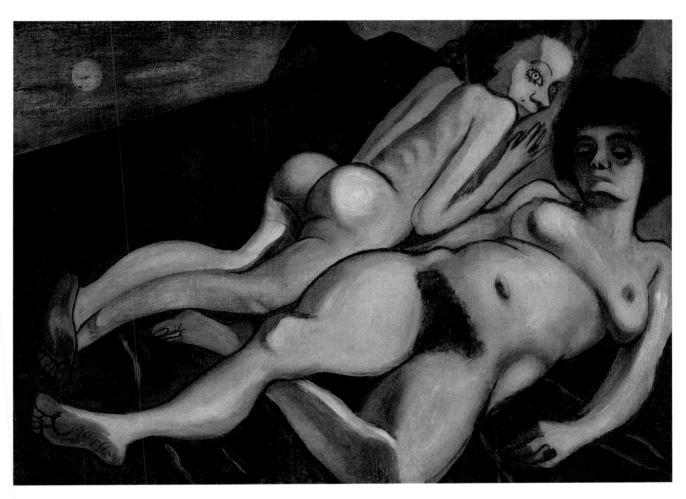

Plate 108
Nadya and Nona
1933. Oil on canvas. 26 × 35½ in. (66 × 90.2 cm.)

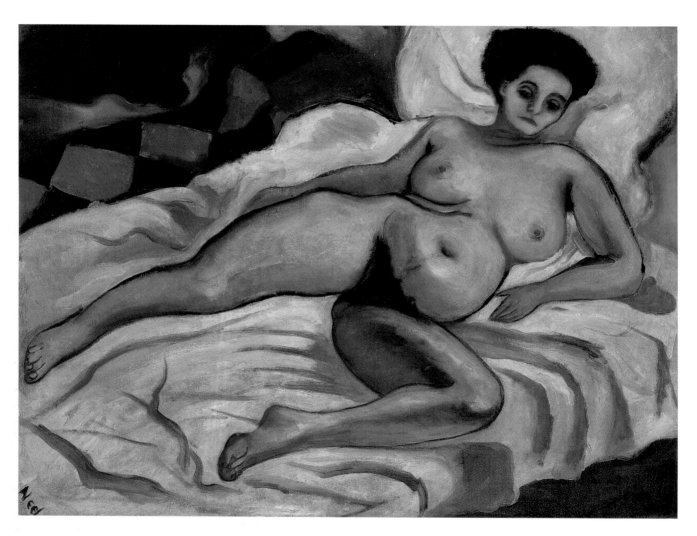

Plate 109
Nadya Nude
1933. Oil on canvas. 24 × 31 in. (61 × 78.7 cm.)

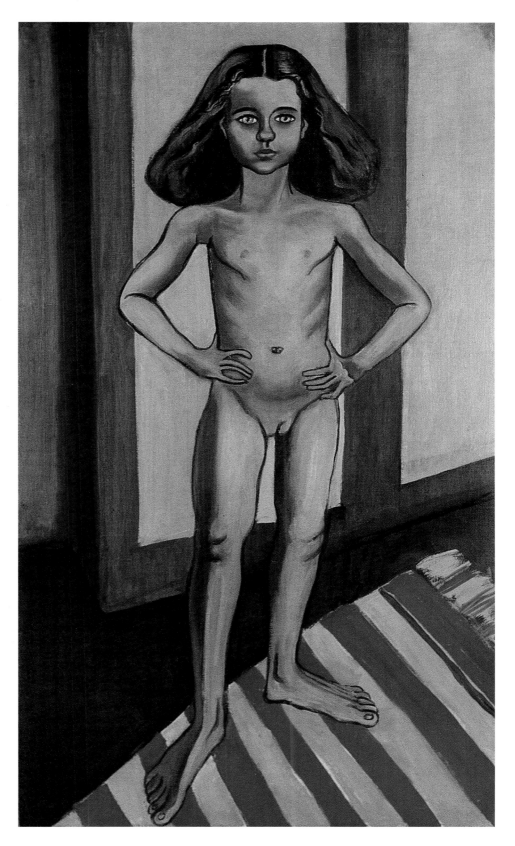

Plate 110
Isabetta
1934. Oil on canvas. 43 × 26 in. (109.2 × 66 cm.)

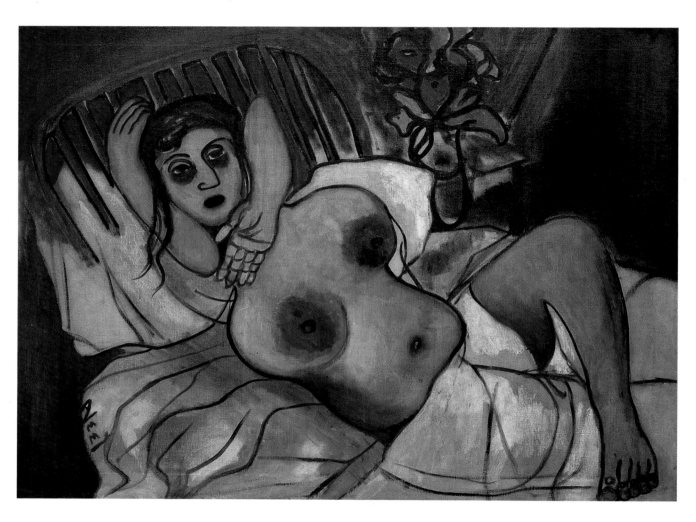

Plate 111
Childbirth
1939. Oil on canvas. 30 × 39¾ in. (76.2 × 101 cm.)

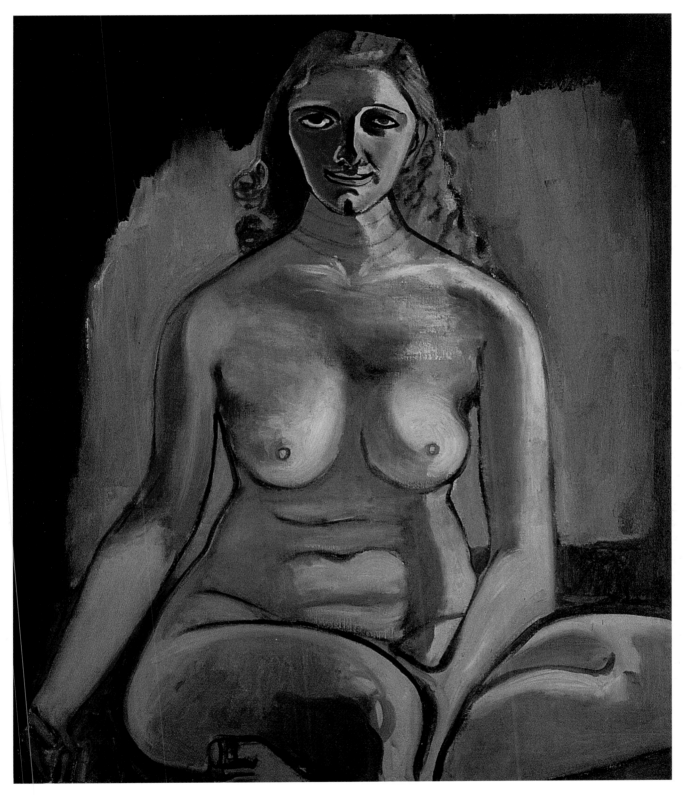

Plate 112
Winifred Messmer
1940. Oil on canvas. 36 × 30 ⅛ in. (91.4 × 76.5 cm.)

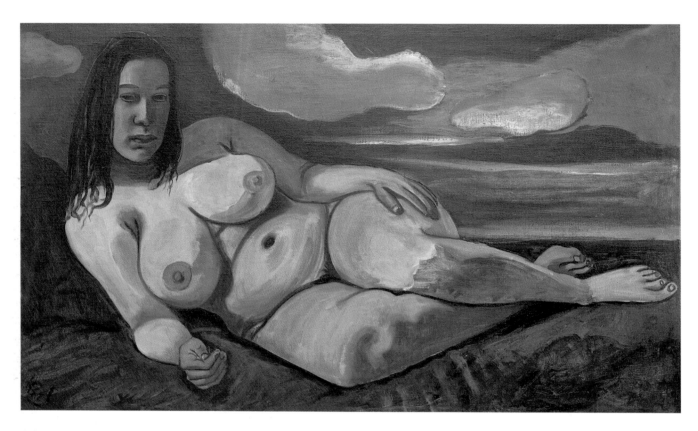

Plate 113
Sue Seely, Nude
1943. Oil on canvas. 30 × 48 in. (76.2 × 121.9 cm.)

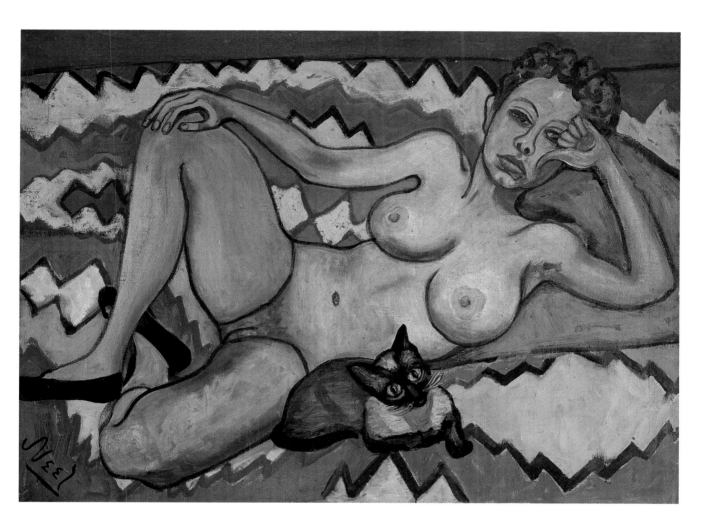

Plate 114
Pat Ladew
1949. Oil on canvas. 26 × 34 in. (66 × 86.4 cm.)

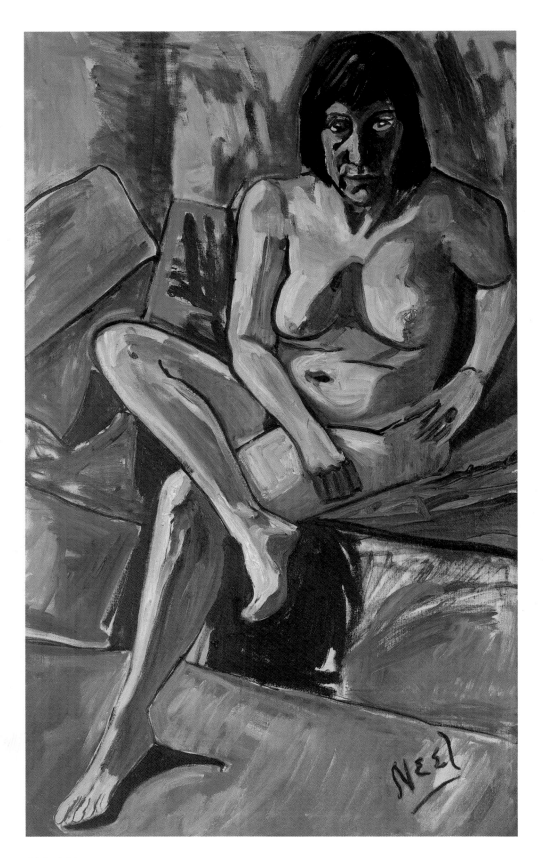

Plate 115
Lida, Nude
1960. Oil on canvas. 50⅛ × 30⅛ in. (127.3 × 76.5 cm.)

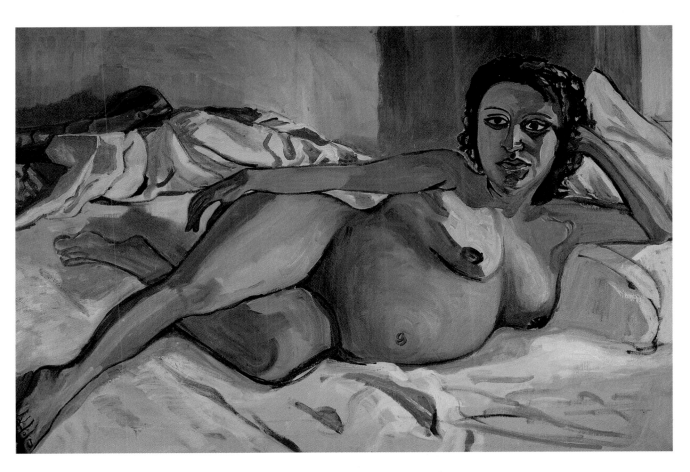

Plate 116
Pregnant Maria
1964. Oil on canvas. 32 × 47 in. (81.3 × 119.4 cm.)

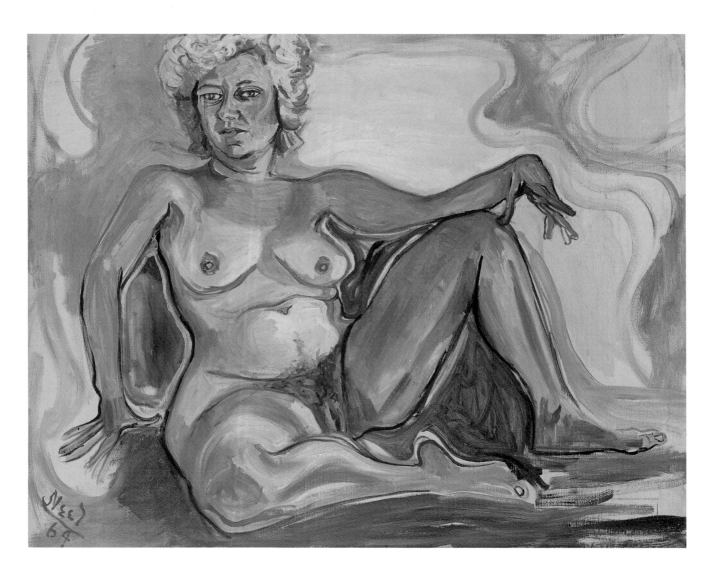

Plate 117
Ruth, Nude
1964. Oil on canvas. 40¼ × 48 in. (102.2 × 121.9 cm.)

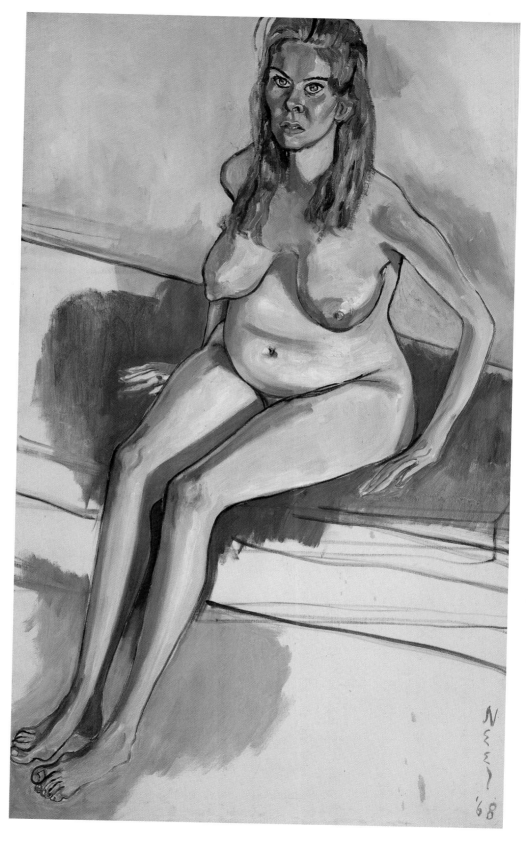

Plate 118
Pregnant Betty Homitzky
1968. Oil on canvas. 60 × 36 in. (152.4 × 91.4 cm.)

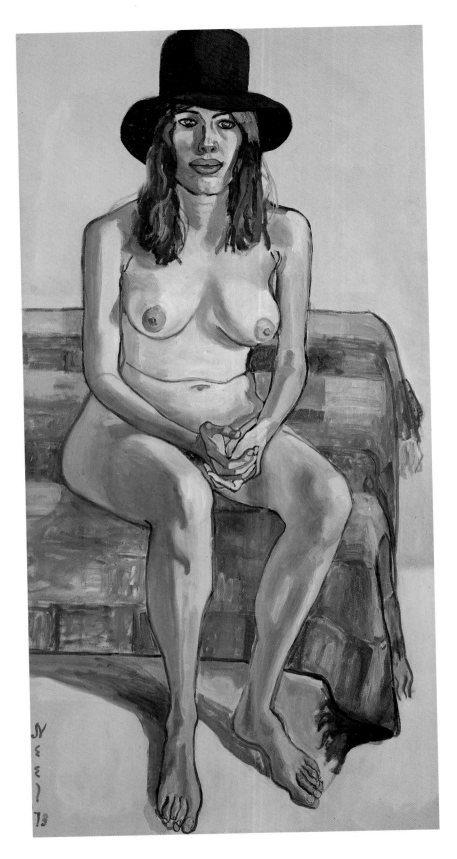

Plate 119
Kitty Pearson
1973. Oil on canvas. 60 × 30 in. (152.4 × 76.2 cm.)

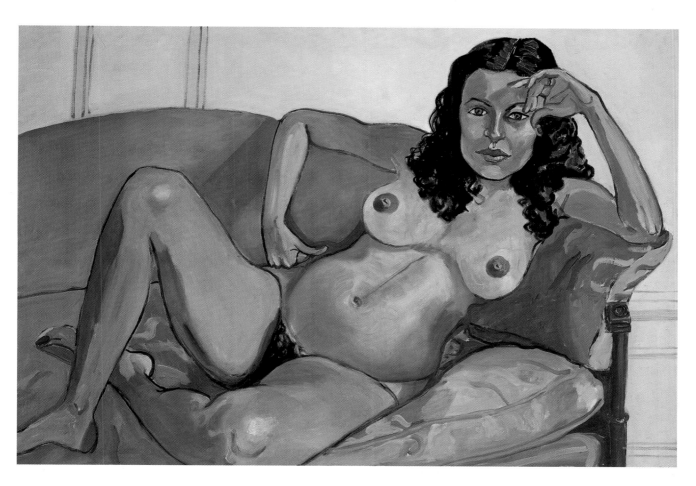

Plate 120
Claudia Bach, Pregnant
1975. Oil on canvas. 45⅞ × 31⅞ in. (116.5 × 81 cm.)

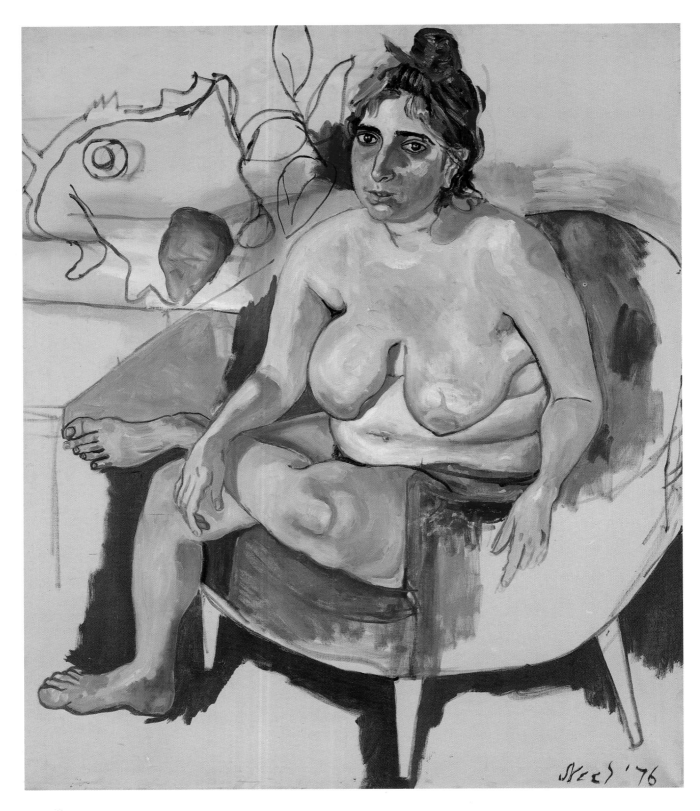

Plate 121
Aryomni
1976. Oil on canvas. 46 × 38 in. (116.8 × 96.5 cm.)

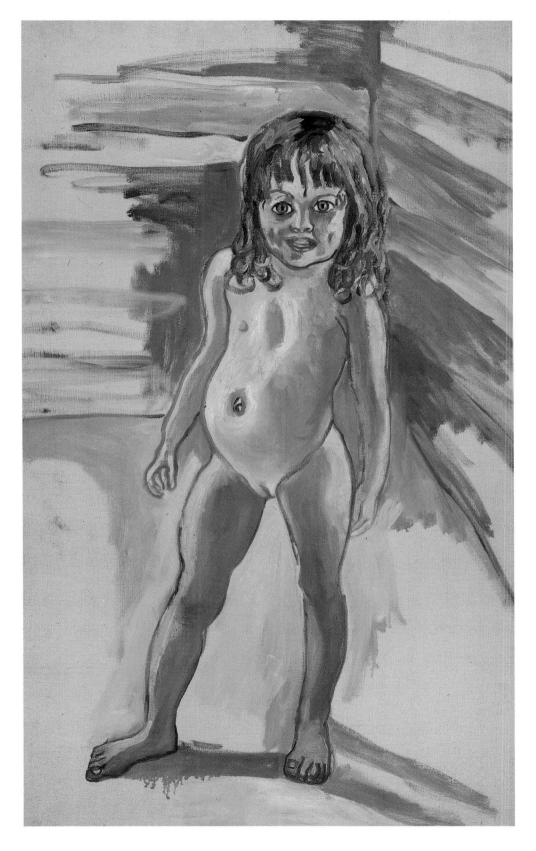

Plate 122
Elizabeth
1977. Oil on canvas. 40 × 24 in. (101.6 × 61 cm.)

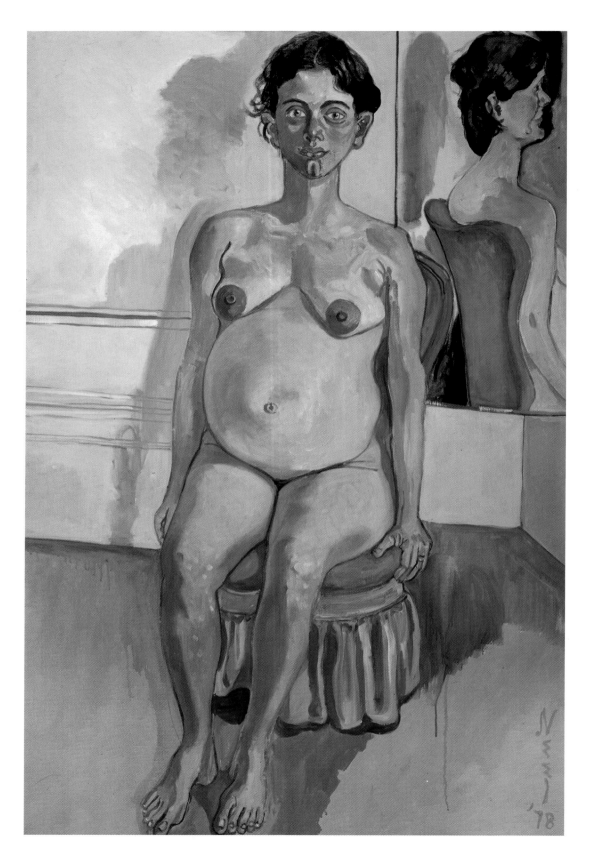

Plate 123
Margaret Evans Pregnant
1978. Oil on canvas. 57 ¾ × 38 in.(146.7 × 96.5 cm.)

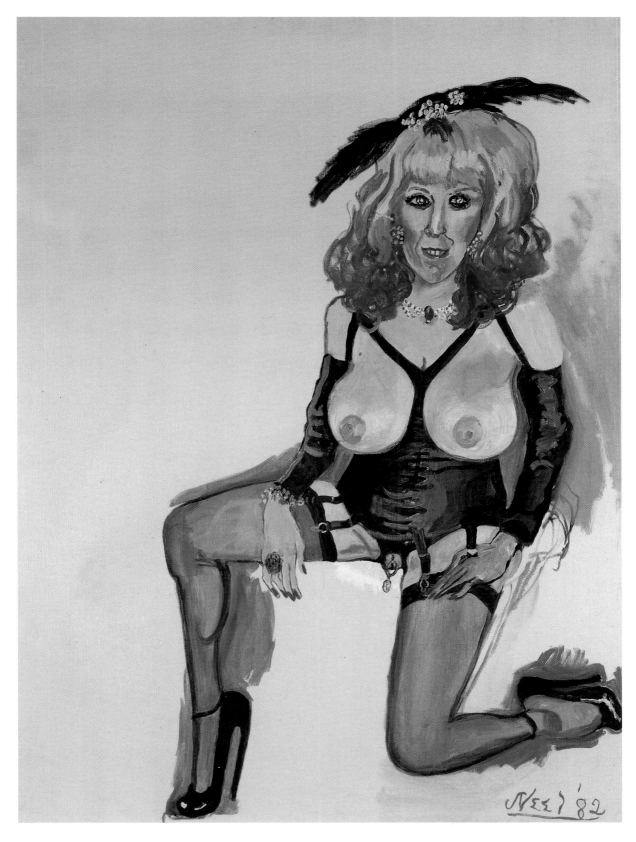

Plate 124
Annie Sprinkle
1982. Oil on canvas. 60 × 44 in. (152.4 × 111.8 cm.)

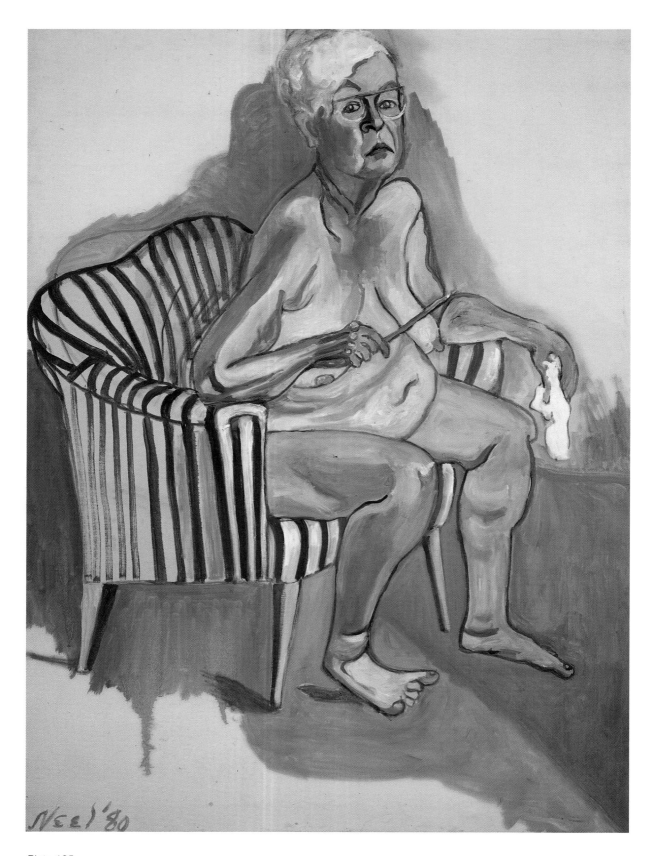

Plate 125
Self Portrait
1980. Oil on canvas. 54 × 40 in. (137.2 × 101.6 cm.)

Selected Bibliography

Allara, Pamela. *Pictures of People: Alice Neel's American Portrait Gallery.* Hanover, New Hampshire: Brandeis University Press and the University Press of New England, 1998.

Belcher, Gerald L., and Margaret L. Belcher. *Collecting Souls, Gathering Dust: The Struggles of Two American Artists, Alice Neel and Rhoda Medary.* New York: Paragon House, 1991.

Carr, Carolyn K., and Ellen Miles. *A Brush with History: Paintings from the National Portrait Gallery.* Washington, D.C.: National Portrait Gallery, 2001.

Castle, Ted. "Alice Neel." *Artforum* 22 (October 1983): 36–41.

Crehan, Hubert. "Introducing the Portraits of Alice Neel." *ArtNews* 61 (October 1962): 44–47, 68.

Hanson, Ann Coffin. *Manet and the Modern Tradition.* New Haven: Yale University Press, 1975; reprint, 1979.

Harris, Ann Sutherland. *Alice Neel Paintings 1933–1982.* Los Angeles: Loyola Marymount University, 1983.

Hills, Patricia. *Alice Neel.* New York: Harry N. Abrams, 1983; reprint, 1995.

Johnson, Ellen H. "Alice Neel's Fifty Years of Portrait Painting." *Studio International* 193, no. 987 (May–June 1977): 174–79.

Lipton, Eunice. "Manet: A Radicalized Female Imagery." *Artforum* 13 (March 1975): 48–53.

Mercedes, Rita. "The Connoisseur Interview: Alice Neel Talks with Rita Mercedes." *The Connoisseur* 208 (September 1981): 2–3.

Nemser, Cindy. "Alice Neel: Portraits of Four Decades." *Ms.* 2 (October 1973): 48–53.

———. "Alice Neel–Teller of Truth," in *Alice Neel: The Woman and her Work,* n.p. Athens: Georgia Museum of Art, 1975.

———, ed. *Art Talk: Conversations with Twelve Women Artists.* New York: Charles Scribners' Sons, 1975.

Nochlin, Linda. "Why Have There Been No Great Women Artists?" *ArtNews* 69 (January 1971): 29–39ff.

Reff, Theodore. "The Meaning of Manet's Olympia." *Gazette des Beaux-Arts* ser. 6, vol. 63 (February 1964): 111–22.

Richard, Paul. "Appreciation: Alice Neel, Painting's Piercing Soul." *Washington Post,* 16 October 1984: sec. B, pp. 1, 4.

Saltz, Jerry. "Painter Laureate: Alice Neel's Symbols." *Arts Magazine* 66 (November 1991): 25–26.

Solomon, Elke M. *Alice Neel.* New York: Whitney Museum of American Art, 1974.

Sozanski, Edward J. "Sitting for Alice." *Philadelphia Inquirer,* 25 June 2000, sec. I, p. 13.

Temkin, Ann, ed. *Alice Neel.* Philadelphia: Philadelphia Museum of Art, 2000.

Selected Public Collections

Allen Art Museum
Oberlin College
Oberlin, Ohio

Apostolic Delegation
Embassy Row
Washington, D.C.

Archer M. Huntington Art Gallery
University of Texas at Austin
Austin, Texas

The Art Institute of Chicago
Chicago, Illinois

The Art Museum
Princeton University
Princeton, New Jersey

The Baltimore Museum of Art
Baltimore, Maryland

Brooklyn Museum of Art
Brooklyn, New York

Columbia University
New York, New York

The Columbus Museum
Columbus, Georgia

David Winton Bell Gallery
List Art Center, Brown University
Providence, Rhode Island

Davison Art Center
Wesleyan University
Middletown, Connecticut

Denver Art Museum
Denver, Colorado

Dillard Institute
New Orleans, Louisiana

Elvehjem Museum of Art
University of Wisconsin at Madison
Madison, Wisconsin

Georgia Museum of Art
University of Georgia
Athens, Georgia

Greenville County Museum of Art
Greenville, South Carolina

High Museum of Art
Atlanta, Georgia

Hirshhorn Museum and Sculpture Garden
Smithsonian Institution
Washington, D.C.

Honolulu Academy of Arts
Honolulu, Hawaii

Hood Museum of Art
Dartmouth College
Hanover, New Hampshire

J.B. Speed Art Museum
Louisville, Kentucky

The Jewish Museum
New York, New York

Ludkin Collection
Chicago, Illinois

The Marion Koogler McNay Art Museum
San Antonio, Texas

The Metropolitan Museum of Art
New York, New York

M.H. de Young Memorial Museum
San Francisco, California

Middlebury College Museum of Art
Middlebury, Vermont

Milwaukee Art Museum
Milwaukee, Wisconsin

The Montclair Art Museum
Montclair, New Jersey

Museum of Art, Olin Arts Center
Bates College
Lewiston, Maine

Museum of Art
Rhode Island School of Design
Providence, Rhode Island

The Museum of Contemporary Art
Los Angeles, California

The Museum of Fine Arts
Boston, Massachusetts

The Museum of Modern Art
New York, New York

Museum of the City of New York
New York, New York

National Gallery of Art
Washington, D.C.

National Museum of American Art
Washington, D.C.

The National Museum of Women in
the Arts
Washington, D.C.

The National Portrait Gallery
Smithsonian Institution
Washington, D.C.

Philadelphia Museum of Art
Philadelphia, Pennsylvania

The Picker Art Gallery
Colgate University
Hamilton, New York

The Schomburg Center for Research in
Black Culture
New York, New York

Sheldon Memorial Art Gallery
University of Nebraska
Lincoln, Nebraska

Smith College Museum of Art
Northampton, Massachusetts

Tacoma Art Museum
Tacoma, Washington

Tate Gallery
London

Tufts University Gallery
Medford, Massachusetts

Whitney Museum of American Art
New York, New York

Yale University Art Gallery
New Haven, Connecticut

Credits

Unless otherwise noted, all works are in the collections of Richard Neel, Hartley S. Neel, their respective families or Neel Arts, Inc.

Assistance with research and documentation was graciously provided by Robert Miller Gallery.

Figure 1
The Family, 1927
Private collection

Figure 2
The Family, 1927
Private collection

Figure 4
Futility of Effort, 1930
Private collection

Figure 5
Symbols, c.1933
Private collection

Figure 6
The Intellectual, 1929
Private collection

Figure 7
Nadya, c.1932
Private collection

Figure 8
Suicidal Ward, Philadelphia General Hospital, 1931
Collection of Stewart R. Mott

Figure 14
Jenny, 1969
Jenny Brand Nelson and Ted Nelson, Massachusetts

Figure 21
Alice by Alice, 1932
Private collection

Plate 10
Carmen and Judy, 1972
Private collection

Plate 11
Linda Nochlin and Daisy, 1973
Courtesy Museum of Fine Arts, Boston

Plate 12
Nancy and Victoria, 1974
Private collection

Plate 13
Ginny and Elizabeth, 1975
Collection of Rett and Carol LeMoult

Plate 17
Fanya, 1930
Private collection

Plate 18
Elenka, 1936
The Metropolitan Museum of Art, New York

Plate 20
Art Dealer, 1942
Private collection

Plate 22
Spanish Woman, c. 1950
Private collection

Plate 26
Suzanne Moss, 1962
Elvehjem Museum of Art, University of Wisconsin-Madison, Gift of Debra and Robert Nathan Mayer from the Robert B. Mayer Memorial Loan Collection, 1984.5

Plate 28
Julie Hall, 1964
Private collection

Plate 30
Marilyn Rabinowich, 1968
Private collection

Plate 31
Helen Merrell Lynd, 1969
National Portrait Gallery, Smithsonian Institution

Plate 33
Dorothy Gillespie, 1975
Collection of Jerome and Phyllis Rappaport

Plate 34
Marilyn Farber, 1977
Private collection

Plate 35
Betsy, 1979
Private collection

Plate 36
Toni Schulman, 1980
Toni Schulman, New York

Plate 37
Blanche Angel, Pregnant, 1937
Whitney Museum of American Art, New York. Purchase with funds from the Drawing Committee

Plate 45
Last Sickness, 1953
Philadelphia Museum of Art

Plate 46
Nurse, 1954
Private collection

Plate 47
Woman Playing Cello, 1955
Sarabelle Miller, New York

Plate 49
Christy White, 1958
Private collection

Plate 50
Religious Girl, 1958
Collection of John Cheim

Plate 54
Nancy Selvage, 1968
Private collection

Plate 60
June Blum, 1972
Private collection

Plate 61
Dianne Vanderlip, 1973
Collection of Sarah Jay Vanderlip

Plate 62
Diane Cochrane, 1973
Private collection

Plate 63
Isabel Bishop, 1974
The Montclair Art Museum Permanent Collection. Museum Purchase, National Endowment for the Arts Museum Purchase Plan, 77.43

Plate 65
Ellen Johnson, 1976
Allen Memorial Art Museum, Oberlin College, Ohio. R.T. Miller Jr. Fund and gift of the artist in honor of Ellen Johnson on the occasion of her retirement

Plate 66
Sari Dienes, 1976
Hirshhorn Museum and Sculpture Garden, Smithsonian Institution, Museum Purchase, 1976.

Plate 67
Faith Ringgold, 1977
Exxon Mobil Corporation, Irving, Texas

Plate 68
Marisol, 1981
Honolulu Academy of Art. Purchase, gifts of Clare Boothe Luce and Mr. and Mrs. Howard Wise, by exchange; Prisanlee and Robert Allerton Funds, 1988

Plate 71
Catherine Jordan, 1983
Collection of Vernon and Amy Faulconer, Dallas, Texas

Plate 74
Mildred, c. 1937
San Diego Museum of Art Bequest of Stanley K. Oldden

Plate 76
Woman in Pink Velvet Hat, 1944
Philadelphia Museum of Art. Gift of the Estate of Arthur M. Bullowa, 1993

Plate 80
Ellie Poindexter, 1962
Private collection

Plate 84
Louise Lieber, 1971
Private collection

Plate 85
Ginny with Yellow Hat, 1971
The Art Institute of Chicago

Plate 86
Olivia in Red Hat, 1974
Private collection

Plate 90
Mary D. Garrard, 1977
Private collection

Plate 91
Vivien Leone, 1983
Private collection

Plate 93
Isabetta, 1930
Collection of Monika and Jonathan Brand

Plate 94
Three Puerto Rican Girls, 1955
Private collection

Plate 95
Two Girls, Spanish Harlem, 1959
Private collection

Plate 97
Swedish Girls, 1968
Columbus Museum, Columbus, Georgia

Plate 106
Ethel Ashton, 1930
Tate Gallery, London
American Fund for the Tate

Plate 110
Isabetta, 1934
Collection of Monika and Jonathan Brand

Plate 111
Childbirth, 1939
Private collection

Plate 114
Pat Ladew, 1949
Toni Schulman, New York

Plate 116
Pregnant Maria, 1964
Private collection

Plate 118
Pregnant Betty Homitzky, 1968
Collection of Sandra and Gerald Fineberg

Plate 119
Kitty Pearson, 1973
Tate Gallery, London
American Fund for the Tate

Plate 120
Claudia Bach, Pregnant, 1975
Linda Lee Alter Collection of Art by Women

Plate 123
Margaret Evans Pregnant, 1978
Collection of John McEnroe, New York

Plate 125
Self Portrait, 1980
National Portrait Gallery, Smithsonian Institution